IMAGES
of America

MARYLAND'S
AMUSEMENT PARKS

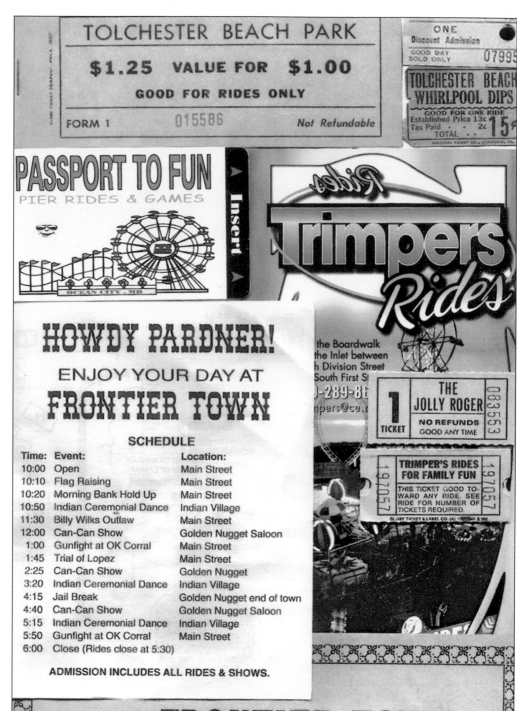

TICKETS AND SOUVENIRS. Tickets, brochures, and souvenirs have been a mainstay of amusement parks since the early 20th century.

IMAGES
of America

MARYLAND'S
AMUSEMENT PARKS

Jason Rhodes

ARCADIA
PUBLISHING

Published by Arcadia Publishing
Charleston, South Carolina

Printed in the United States of America

Library of Congress Catalog Card Number: 2005920610

For all general information contact Arcadia Publishing at:
Telephone 843-853-2070
Fax 843-853-0044
E-mail sales@arcadiapublishing.com
For customer service and orders:
Toll-Free 1-888-313-2665

Visit us on the Internet at www.arcadiapublishing.com

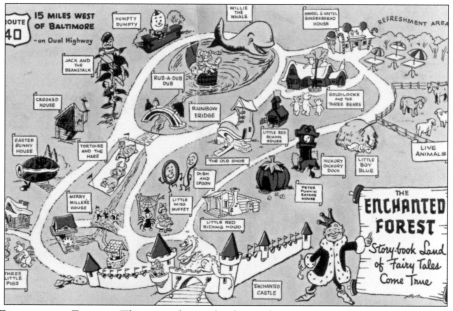

THE ENCHANTED FOREST. This map shows the fairy tale attractions that existed at Maryland's first theme park on opening day, August 15, 1955. During dedication ceremonies a day earlier, park owner Howard E. Harrison Sr. proclaimed, "There are no mechanical rides in the park. Instead we hope that the children will enjoy the make-believe figures that are before their eyes." Opening in Ellicott City less than a month after the nation's first theme park, California's Disneyland, the attraction was billed as the second theme park in the United States and the first on the East Coast. During The Enchanted Forest's first year, *Today* TV news magazine announcer Jack Lescoulie and simian sidekick J. Fred Muggs broadcasted from the park, making it the second theme park ever seen on television. The Enchanted Forest originally measured 20 acres and later grew to 52 with new attractions and exhibits. Howard L. Adler of Baltimore's famed Adler Display Company oversaw the creation of each of the original exhibits. Admission in 1955 was $1 for adults, 50¢ for children.

CONTENTS

ACKNOWLEDGMENTS

Undertaking any project of this size would be impossible without assistance from many individuals and organizations dedicated to keeping the memories of Maryland's amusement parks alive.

The author extends thanks to the following people for their help in making this book a reality: Bill Betts, Richard A. Cook, Sara Cox, Taylor Jeffs, Jacques Kelly, Monica McNew-Metzger, Nan Sherman, Carol Brewington Smith, Christine Smith, Harriet Stout, Dixie Stumpf, and Monica Thrash.

Thanks also go to the following organizations for supplying images and information: Baltimore Streetcar Museum, Chesapeake Beach Railway Museum, Enchanted Forest Preservation Society, Library of Congress Prints and Photographs Division, Maryland Department of Natural Resources, Maryland Historical Society, Maryland State Archives, National Park Service, Prince George's County Historical Society, Tolchester Beach Revisited, Trimper's Rides and Amusements, and University of Maryland Libraries Division of Collection Management and Special Collections.

Special thanks go to Frank and Harriet Rhodes and Alice Middleton for their support during this and most other projects in the author's life.

Pictures for which no credit is given are from the author's collection.

INTRODUCTION

Amusement parks have been a part of the American landscape since the early 1800s when European immigrants brought with them the concept of the carousel and the dedication of open spaces to public recreation.

The Scenic Railway appeared in 1887, a slower precursor to the first modern roller coaster constructed by amusement pioneer L.A. Thompson in Coney Island in 1894. Just three years prior, in 1891, William Somers introduced the country's first pleasure wheel—another attraction based on European design—in Atlantic City, New Jersey. Engineer George Ferris popularized a steel version during the 1893 Columbian Exposition in Chicago, and the ride has carried his name ever since.

Maryland saw its first amusement parks of record in the late 19th century thanks in large part to the companies that owned steamboats and trains, which provided the bulk of the state's transportation. These companies, not content just to get people where they wanted to go, sought to increase ridership by offering patrons recreational destinations such as Pen Mar Park in Western Maryland and Tolchester Beach Park on the Eastern Shore. These practices continued into the early 1900s, when trolley companies used the same methods—and surplus electricity allotments—to lure families to new parks in Baltimore and the suburbs of Washington, D.C.

Amusement parks also helped draw people to Maryland's resorts. This was the case both with the state's first amusement park, Cabin John Park in Montgomery County, and the everlasting Trimper's Rides and Amusements, today the oldest amusement park in Maryland.

Following World War II, fairy tale–themed parks cropped up across the United States as families sought even more recreational opportunities. These parks gave birth to the concept of the theme park, popularized by Walt Disney with the opening of Disneyland in July 1955. The Enchanted Forest in Ellicott City, Maryland, was heralded as the nation's second theme park upon its opening less than a month later. Ocean City's Frontier Town and Baltimore's Power Plant followed this concept in later years.

By the 1970s, many of Maryland's amusement parks had closed or were on the verge of shutting their gates forever as public favor turned to larger theme parks in surrounding areas, including Pennsylvania's Hersheypark and Virginia's Kings Dominion and Busch Gardens. Today, Maryland has its own counterpart to these megaparks, Six Flags America in Largo. While that operation and smaller parks in Ocean City—supported by summer resort crowds—continue to thrive, most other parks in the state are but memories.

7

That is especially true for this handful of parks for which no photographs could be located for inclusion in this book.

• Bethesda Park was founded as a trolley park in Montgomery County by entrepreneurs Richard Drum and John Beall in 1891. The 50-acre park featured flying horses, swings, a shooting gallery, a dance hall, a zoo, and an indoor botanical garden. By its second season, its owners had added a restaurant and a $10,000 carousel. A roller coaster and Ferris wheel soon followed, as did a variety of midway games, a theater, and a bowling alley. An electrical fire caused the park's demise in 1894.

• Notley Hall Amusement Park, in Prince George's County, served the area's African-American population on the Potomac River from about 1894 to 1924. The steamboat *River Queen* ran excursions to the establishment, re-named Washington Park in 1911. Its attractions included a bowling alley, horseback rides, swings, a shooting gallery, and flying horses.

• Hollywood Park was well known in the early 20th century. Located on Back River at Eastern Avenue in Baltimore, the park earned the reputation of being a place where one could "escape the horrors of reality," as praised by *Baltimore Morning Herald* and *Sun* columnist H.L. Mencken.

• Lakeside Park served the residents of northern Baltimore on Lake Roland starting in the early 1900s. This was another trolley park; its main pavilion stood until arson claimed the structure in the 1960s.

• Wonderland Park was another Baltimore amusement park about which little is known.

• Asbury Park was located just outside Crisfield in Somerset County. The park included a Tumble Bug ride (cars moving along a hilly circular track) and a roller skating rink. It was destroyed by fire sometime in the early 20th century.

• Bay Ridge Park, located in Crisfield's LaVallettes section, was a waterfront park that at various times included flying horses, a Ferris wheel, a lighted swimming pool, and seaplane rides. Tokens inscribed with the park's name granted entry to the attractions. The park operated in the 1930s. Hurricane Hazel washed away all traces of the park, including the land on which much of it sat, in 1954.

Images of America: *Maryland's Amusement Parks* is dedicated to preserving the memories of those parks and others like them from the late 18th century to today. For the purposes of this book, an amusement park is defined as a permanent public area with rides, shows, or other attractions operated by a single company. This does not include seasonal fairs, traveling carnivals, municipal carousels, independently operated boardwalk attractions, or rideless amusement piers and resorts, also important to Maryland's heritage but too numerous to list here.

Nearly everyone has a favorite amusement park memory. This book is meant to preserve the images that have surrounded many of those memories in Maryland.

One

WESTERN MARYLAND PARKS

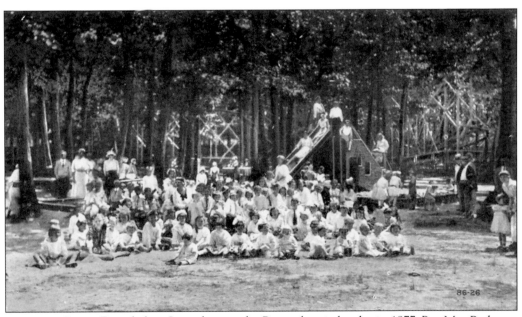

PEN MAR PARK. Founded in Cascade near the Pennsylvania border in 1877, Pen Mar Park was created by the Western Maryland Railroad Company to increase ridership by offering a resort destination. One of the most popular early attractions for children was the sand pile and slide at the park's picnic grove, seen here around 1910. A close look at the background reveals the supports for the park's figure-eight roller coaster.

EVERYBODY'S DAY. Traditionally held the third week in August, Everybody's Day celebrated Pen Mar Park's attractions with a baby show featuring up to 500 contestants annually. This image, c. 1910, shows the Washington County park's dance pavilion, at left, and the first motion picture theater, at right. The theater was rebuilt in 1914 after heavy snow collapsed its roof while the park was closed for the season.

AMUSEMENT SECTION. This building housed the 52-animal, 2-chariot Dentzel/Muller Brothers carousel that served the park from 1907 until its sale to the Greatlander Resort in Alaska in 1944. The carousel was permanently dismantled there in 1967. Throughout the years, Pen Mar's carousel building also housed a penny arcade, a hall of mirrors, various games of chance, and a shooting gallery, the latter of which is seen to the left in this view, c. 1910.

10

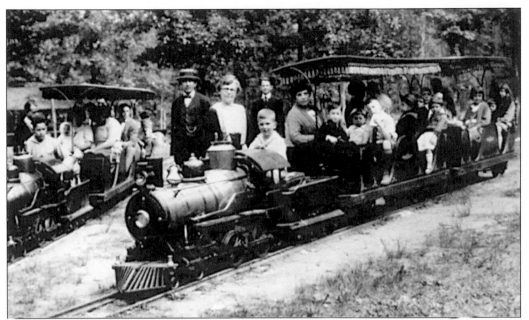

THE LITTLE WABASH RAILROAD. It was only fitting that an amusement park operated by a full-fledged railroad have a miniature version for its patrons. Pen Mar's opened in 1904 and was dubbed the "Little Wabash." The little railroad's longtime engineer, William Fleigh, replaced the first trains with two newer models originally used at the 1907 Jamestown Exhibition in Virginia. An estimated 750,000 patrons rode the Little Wabash until the park's closing in 1942.

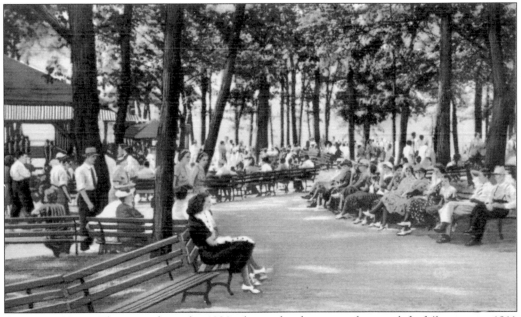

GENERAL VIEW. This view from the 1930s shows the dance pavilion, at left, following its 1911 enlargement and the adjacent miniature train station. The number of benches in this scene demonstrates just how much amusement parks have changed since then. At the time, one of the most popular "amusements" was the ability to sit beneath shade trees in a breezy environment on a hot summer's day.

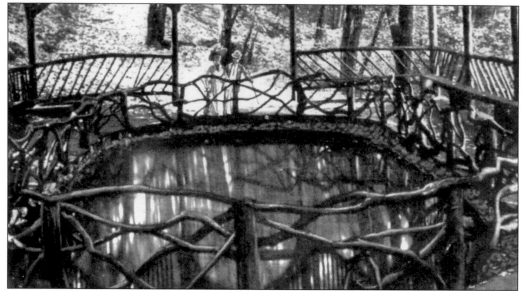

GLEN AFTON SPRING. Not all attractions at Pen Mar Park were man-made. The natural beauty of Glen Afton Spring was one of the park's most aesthetic features. However, the landmark also served a practical use, giving the park its water supply. The ornate railing was constructed in 1879. Nearby, the High Rock Observatory afforded patrons a bird's-eye view of the park and other natural wonders that surrounded it.

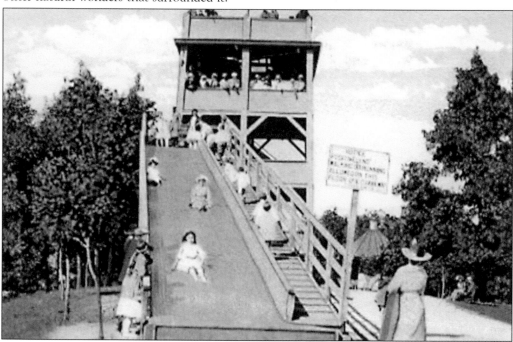

BRADDOCK HEIGHTS SLIDE AND OBSERVATORY. This 40-foot landmark, built in 1894 at Braddock Heights Park in Frederick County, combined two of the biggest attractions of nearby Pen Mar, offering an observation tower and giant slide all in one. This view, c. 1915, shows the all-wood structure before a layer of tin was placed over the slide in 1926. A new observation tower served the area from 1931 until its demolition in 1971. (Courtesy Dixie Stumpf.)

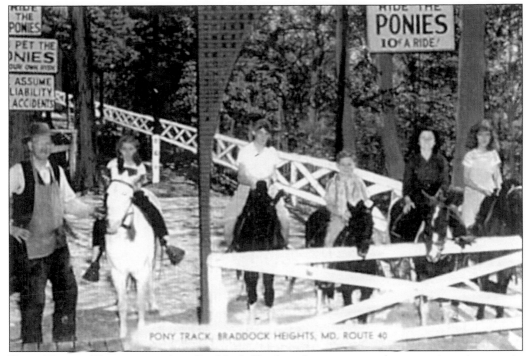

PONY TRACK. The pony track at Braddock Heights also was a popular attraction. As seen in this 1940s view, admission was 10¢ and patrons were advised to pet the animals at their own risk. Animal handler Johnny King operated the attraction. (Courtesy Dixie Stumpf.)

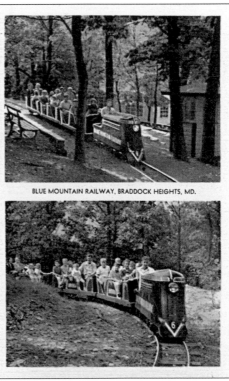

BLUE MOUNTAIN RAILWAY, BRADDOCK HEIGHTS, MD.

BLUE MOUNTAIN RAILWAY. Like those at Pen Mar, the original miniature trains used at Braddock Heights Park originally ran at the 1907 Jamestown Exposition and continued at the park at least until the early 1940s. By the time this postcard was printed a few years later, the engine's style had changed to a sleeker blue model, operating as the "Blue Mountain Railway."

13

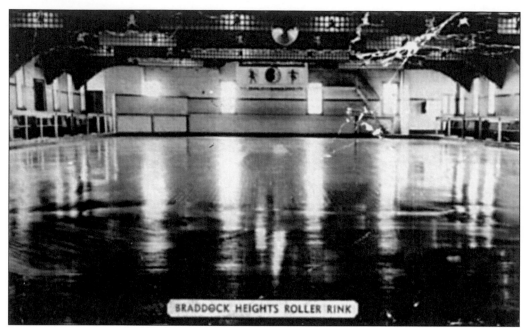

ROLLER RINK. The Braddock Heights roller rink was a mainstay of the community even after the park was closed in 1964. The rink remained popular until its destruction by arson on August 19, 1998. This view shows the building's ornate interior as it appeared in the 1940s. (Courtesy Dixie Stumpf.)

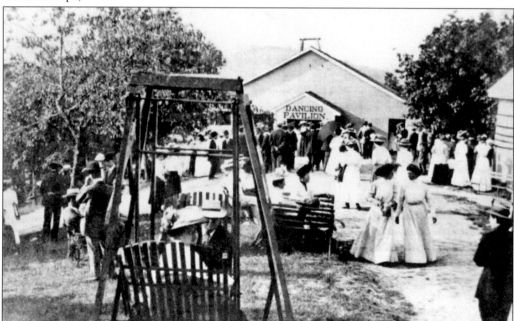

DANCING PAVILION. Built shortly after the observation tower, Braddock Heights's Dancing Pavilion served the area for many decades. Enlarged in 1924 and once again about 10 years later, the pavilion initially hosted a house band led by Joseph Stephens. In later years, contracted bands played at the pavilion until it closed in 1964. Re-opened for a short time in the 1970s, the building sat vacant for years until it burned in 1987.

Two

GLEN ECHO PARK

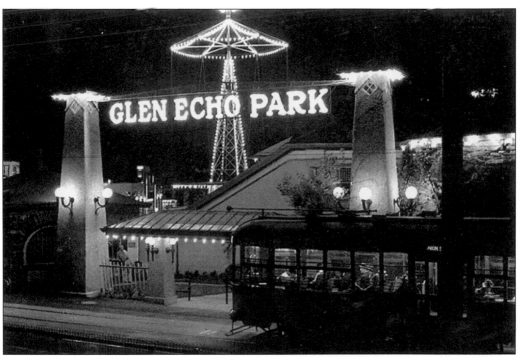

GLEN ECHO PARK. Located in Montgomery County, Glen Echo Park grew from the National Chautauqua Assembly education center, which opened in 1891. Amusements arrived in 1899 when the assembly's operators leased the land to the Glen Echo Company. The Washington Railway and Electric Company, seeking to attract trolley riders to the area, bought the park soon after, making it a permanent fixture until its final season in 1968. (Courtesy Richard A. Cook.)

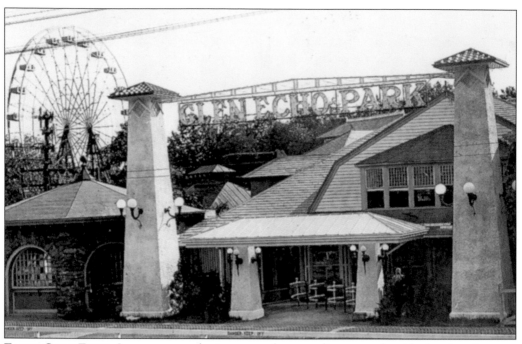

EARLY GLEN ECHO. In contrast to the image on the preceding page, the ride drawing the most gazes from the main entrance during the park's earliest days was not the Aero Swing, but the Ferris wheel, seen in this 1904 view. (Courtesy Richard A. Cook.)

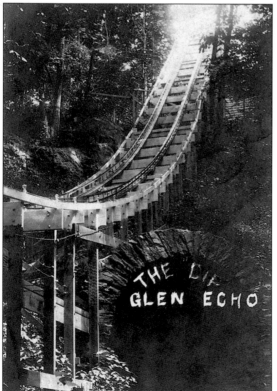

THE DIP. Seen here in 1907, the Dip was unique for its time, when most similar attractions offered only a slight incline as cars leisurely rolled past the surrounding scenery. The Dip added an uncommon thrill to Glen Echo. (Courtesy Richard A. Cook.)

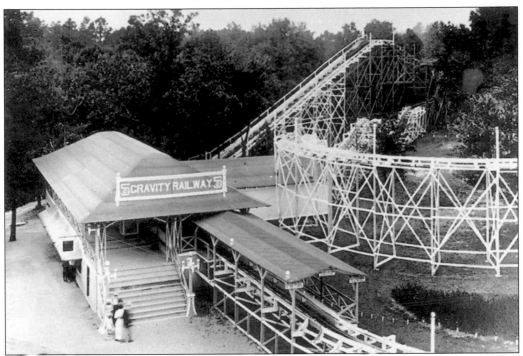

GRAVITY RAILWAY. A more traditional roller coaster, the Gravity Railway expanded on the Dip's thrills as the park matured. Notice the 5¢ admission sign. (Courtesy Richard A. Cook.)

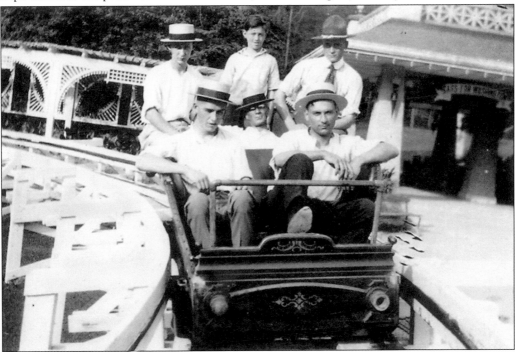

RIDING THE GRAVITY RAILWAY. As its name implied, the Gravity Railway used the earth's natural pull as its main means of propulsion. Despite the ride's rapid nature, these men obviously weren't worried about losing their hats. (Courtesy Richard A. Cook.)

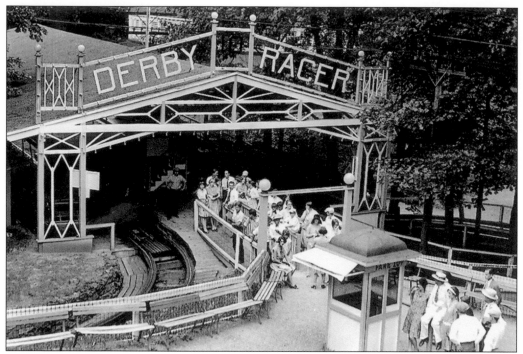

DERBY RACER. Glen Echo had a history of offering elaborate entryways to its roller coasters, and the Derby Racer was no exception. The ride was constructed after the Gravity Railway, and admission climbed to 10¢ per rider. (Courtesy Richard A. Cook.)

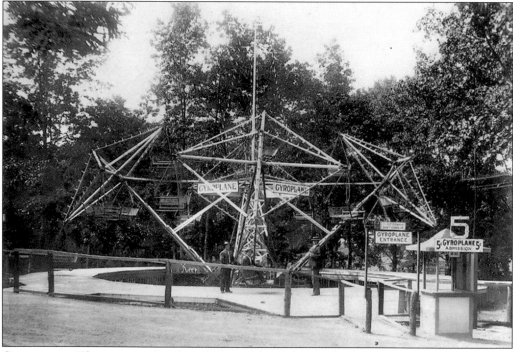

GYROPLANE. This was another 5¢ ride from Glen Echo's early days. A sign in the foreground warns riders not to stand up on the bench-like seats. (Courtesy Richard A. Cook.)

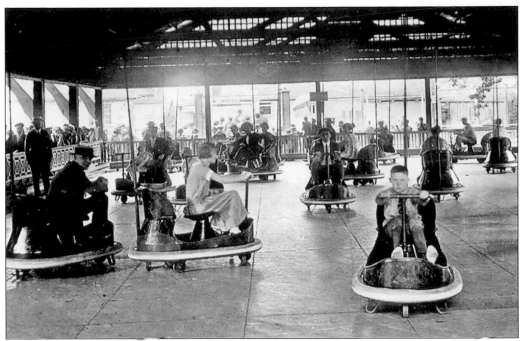

FIRST BUMPER CARS IN THE UNITED STATES. Glen Echo was an innovative amusement park in many ways. In 1923, it became the first amusement park in the United States with a permanent bumper car pavilion, called the Skooter. While the first cars, originally used at the 1920 World's Fair, bore little resemblance to their modern counterparts, they served the same purpose. (Courtesy Richard A. Cook.)

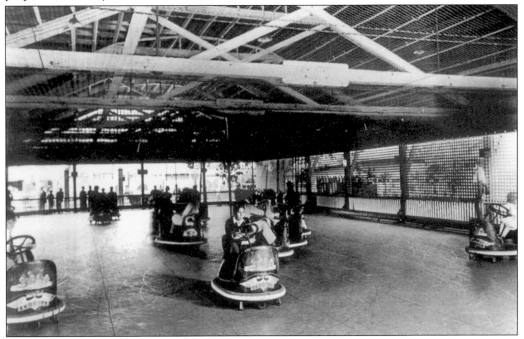

MODERN BUMPER CARS. The first modern bumper cars were installed in the park in 1927. The new cars were based on a design introduced by French amusement pioneer Gaston Reverchon.

19

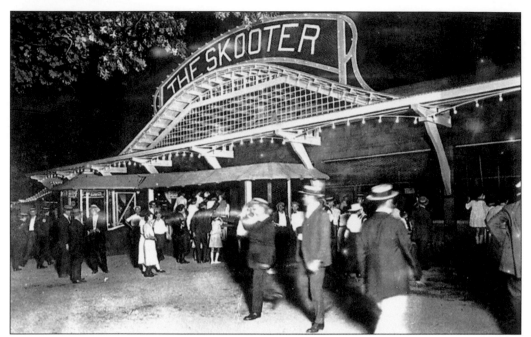

SKOOTER PAVILION. Built in 1923, the Skooter pavilion housed the many historic bumper cars seen in the park through 1968. In the 1930s, the pavilion received an art deco makeover, and the ride was renamed "Dodgem." (Courtesy Richard A. Cook.)

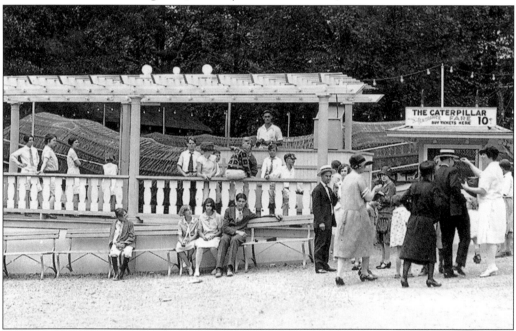

CATERPILLAR. No amusement park of the 1920s was complete without a Caterpillar. The ride is said to have caused panic among some park patrons when first introduced in the United States due in part to the canopy that rose up to cover the track while the cars were in motion. No such incidents of panic are known to have occurred at Glen Echo. The ride attracted hundreds of patrons daily. (Courtesy Richard A. Cook.)

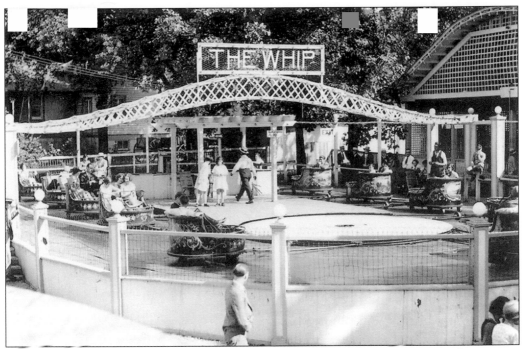

WHIP PAVILION. Adjacent to the Skooter, the Whip was another amusement park mainstay that found a home at Glen Echo. This 1920s photo shows the pavilion during its early days. (Courtesy Richard A. Cook.)

THE WHIP. Inside the pavilion, the ride flung patrons around the outer ends of the oval-shaped track, using centrifugal force to provide its thrills. (Courtesy Richard A. Cook.)

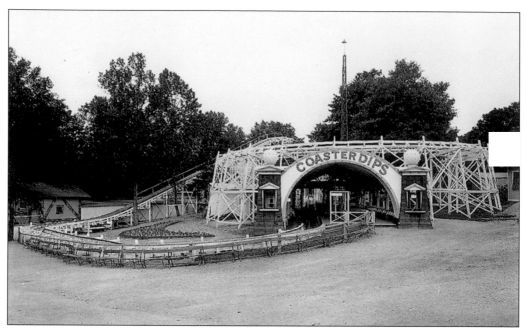

ORIGINAL COASTER DIPS. Glen Echo's signature roller coaster almost did not make it past the first season. The original version, seen here in 1921, did not offer the thrills riders had become accustomed to through such attractions as the Gravity Railway and Derby Racer. (Courtesy Richard A. Cook.)

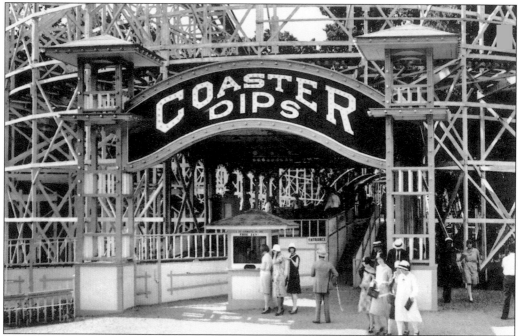

NEW COASTER DIPS. Following a massive renovation, the Coaster Dips re-opened in 1922 as one of the largest and most elaborate roller coasters on the East Coast. The new version became the park's signature ride, operating until 1968. (Courtesy Library of Congress Prints and Photographs Division.)

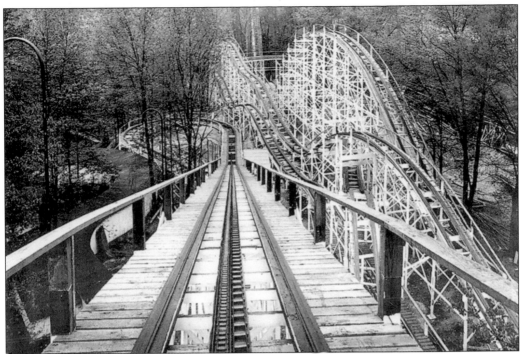

COASTER DIPS. This shot from the Coaster Dips's tallest point shows just how intricate the track layout was, as well as how high riders traveled before speeding down the coaster's first drop. (Courtesy Richard A. Cook.)

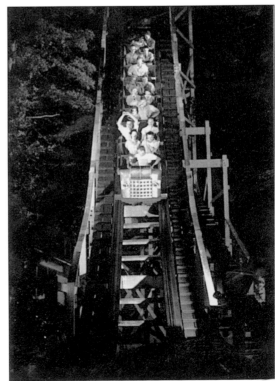

COASTER DIPS. The design of the coaster's cars did not change throughout the rides 46-year history, as evidenced in this view from the 1950s. (Courtesy Richard A. Cook.)

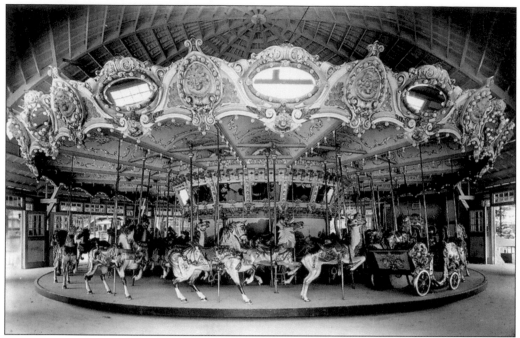

DENTZEL CAROUSEL. Another long-standing piece of the park, the Dentzel carousel, also was installed in 1921. An iconic part of Glen Echo history, the carousel remains at its original site today and is operated each summer by the National Park Service, which has overseen the grounds since 1971. (Courtesy Richard A. Cook.)

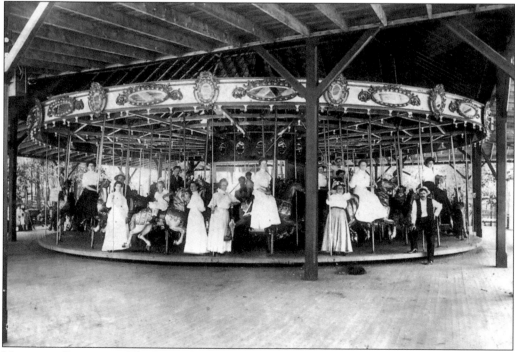

MANGELS CAROUSEL. The Dentzel carousel above replaced the park's 1904 Mangels carousel, seen here. (Courtesy Richard A. Cook.)

REACHING FOR THE BRASS RING. Throughout most of the park's existence, Glen Echo patrons participated in the once-popular amusement park tradition of reaching for rings on the carousel. Any patron lucky enough to snag a brass ring from the dispenser earned a free ride. (Courtesy Richard A. Cook.)

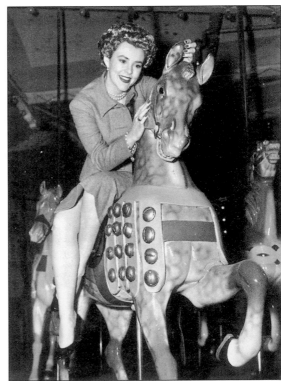

RIDING SIDE-SADDLE. This image of a daring lass riding side-saddle provides a close-up view of one of the hand-carved Dentzel horses that comprised the stylish carousel. (Courtesy Richard A. Cook.)

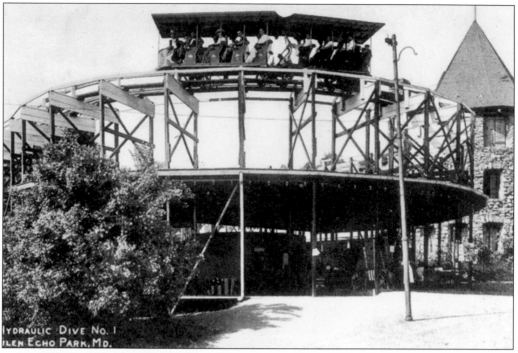

HYDRAULIC DIVE No. 1
GLEN ECHO PARK, MD.

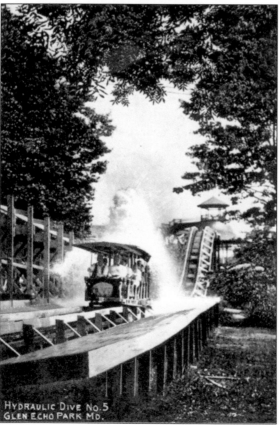

HYDRAULIC DIVE No. 5
GLEN ECHO PARK MD.

THE HYDRAULIC DIVE. One of the most innovative rides designed exclusively for Glen Echo Park was the Hydraulic Dive, which opened about 1906 as a combination of the roller coaster and shoot-the-chutes. Ride operators took patrons to the top of a set of tracks in a vehicle resembling an open-air trolley car (top), then sent the car careening down a hill into a trough of water. The force of the vehicle sent water from the trough through a series of pipes aimed to shoot over the car (bottom).

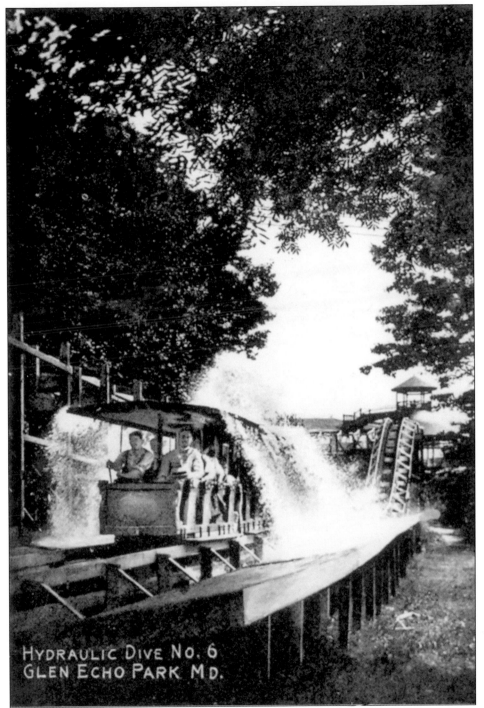

HYDRAULIC DIVE NO. 6
GLEN ECHO PARK MD.

THE HYDRAULIC DIVE. Once at the bottom of the track, the ride operator slammed on the brakes and allowed the water to crash down over the vehicle, giving riders the illusion of an instant waterfall. The ride was popular but short-lived compared to other Glen Echo attractions. Patrons loved it, but ride operators complained of having to spend the day repeatedly getting soaked. (Courtesy Richard A. Cook.)

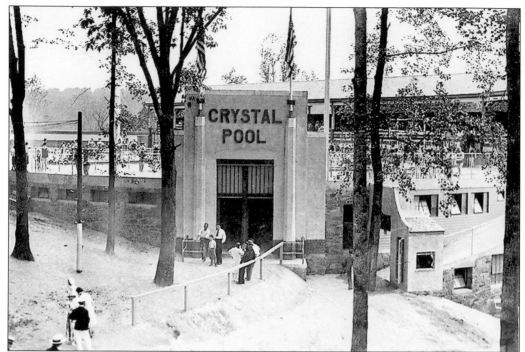

CRYSTAL POOL ENTRANCE. The most popular non-mechanical attraction at Glen Echo was the Crystal Pool, which for years served as a community pool for surrounding neighborhoods. It opened in May, two months after the rest of the park. (Courtesy Richard A. Cook.)

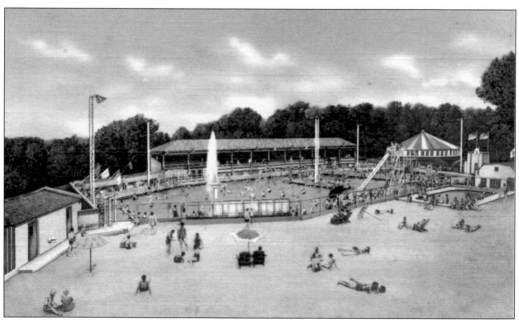

CRYSTAL POOL. Glen Echo patrons knew the Crystal Pool was a cut above most. Featuring such amenities as a fountain, water slide, diving basin, and kiddie area, the pool held 1.5 million gallons of water and had room for 3,000 bathers. It was a hit from its first season in 1931.

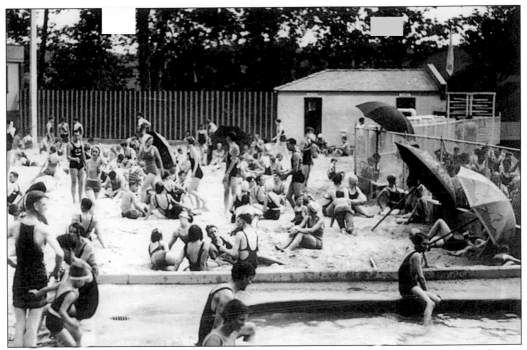

THE BEACH. Adjacent to the Crystal Pool, a beach comprised of real seashore sand gave swimmers the feeling of being at an oceanfront or bayside resort on Maryland's Eastern Shore without ever having to leave the Washington metropolitan area. (Courtesy Richard A. Cook.)

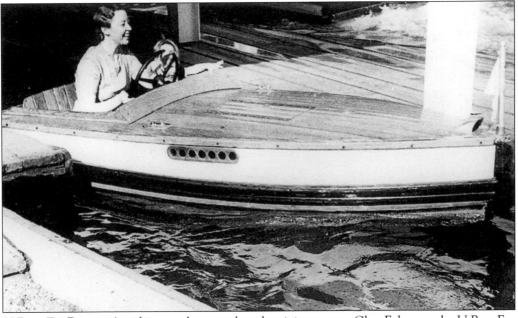

U-RUN-EM BOATS. Another popular water-based activity once at Glen Echo was the U-Run-Em Boats, seen here *c.* 1938. The ride allowed patrons to operate their own gasoline-powered boats along a designated course inside the park. While enthusiasm for the attraction never waned, fuel did. Park officials dry-docked the boats during the gasoline shortage of World War II and never re-opened the ride. (Courtesy Richard A. Cook.)

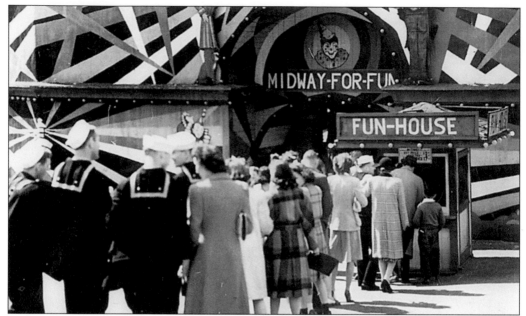

MIDWAY FOR FUN. The Midway for Fun was Glen Echo's multi-faceted fun house. Unlike traditional fun houses, the Midway did not lead patrons through a series of gags. Instead, the entrance led to an auditorium-style building filled with attractions to experience. In this photo, taken during World War I, a sign on the ticket booth lists the price as 15¢ plus a 2¢ war tax. (Courtesy Richard A. Cook.)

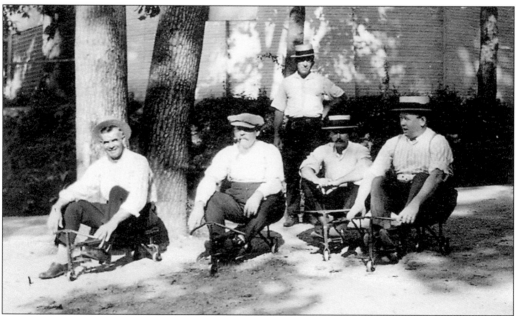

MIDWAY TRICYCLES. One of the more novel attractions inside the Midway for Fun was a group of miniature tricycles without pedals, demonstrated here outside the fun house. An overhead catwalk inside the Midway ran at a slight slope around most of the building's inner circumference. Adults boarded the tricycles and used their body weight to maneuver the vehicles around the platform. (Courtesy Richard A. Cook.)

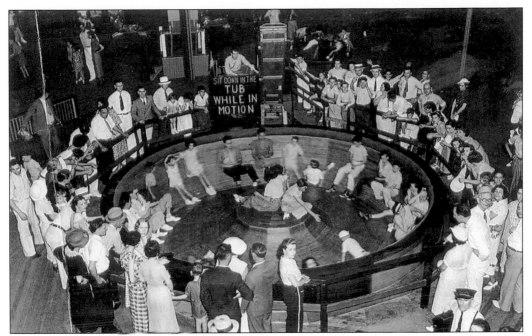

THE TUB. Known as the "Human Roulette Wheel" at other amusement parks, the Tub was another attraction inside Glen Echo's Midway for Fun. Throughout the United States, these devices gained a reputation for being as fun to watch as they were to ride. (Courtesy Richard A. Cook.)

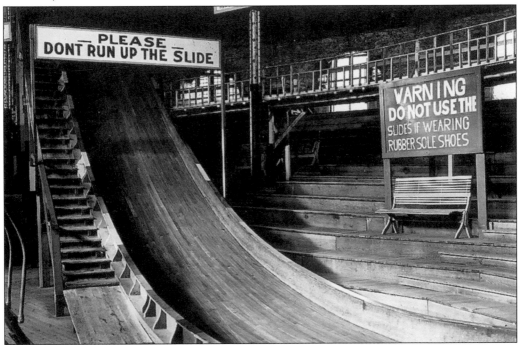

THE SLIDE. No early 20th-century fun house was complete without a wooden slide. Note that part of the tricycle platform is visible to the right above the sign reading, "Warning: Do not use the slides if wearing rubber sole shoes." (Courtesy Richard A. Cook.)

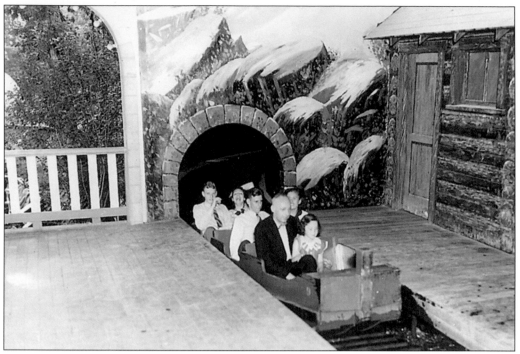

RIDING THE OLD MILL. A tunnel of love–style ride, the Old Mill took patrons past painted flats and dimly lit interiors, giving them a chance to momentarily escape the crowds milling about outside. (Courtesy Richard A. Cook.)

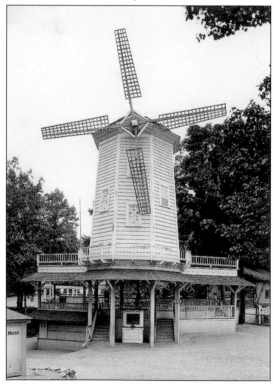

OLD MILL ENTRANCE. The ride's entrance lived up to its name with a giant windmill rising high to summon potential riders to its ticket booth. (Courtesy Richard A. Cook.)

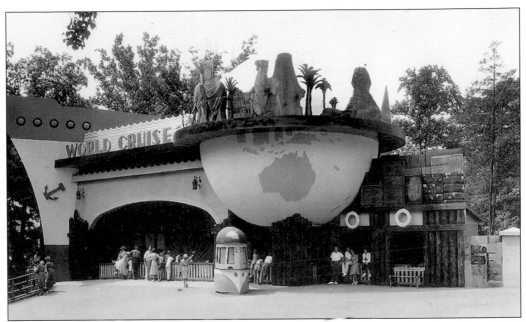

WORLD CRUISE. Park officials replaced the Old Mill with the elaborate facade of the World Cruise in the 1930s. While the ride remained a tunnel of love–style attraction, patrons now found themselves passing painted flats and miniature lights representing specific cities and countries throughout the world. (Courtesy Richard A. Cook.)

THE PRETZEL. Early in the 20th century, the Pretzel Amusement Company set the standard for dark rides throughout the United States. Few amusement parks were without at least an imitation. Glen Echo had an original, and as seen in this World War I–era photo, it was quite popular. Inside, patrons saw a variety of gags ranging from scary to silly. Outside, the sign on the ticket booth reminded them war tax would be added to their admission. (Courtesy Richard A. Cook.)

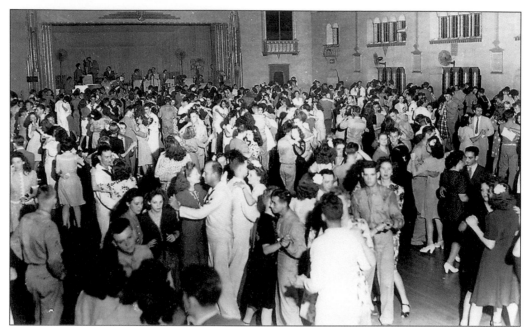

THE BALLROOM. One of only two photos known to exist showing actual dancing in the Glen Echo Ballroom, this image demonstrates how the park was many things to many people. Instead of coming to ride or swim, these people came to dance, and Glen Echo provided the opportunity. (Courtesy Richard A. Cook.)

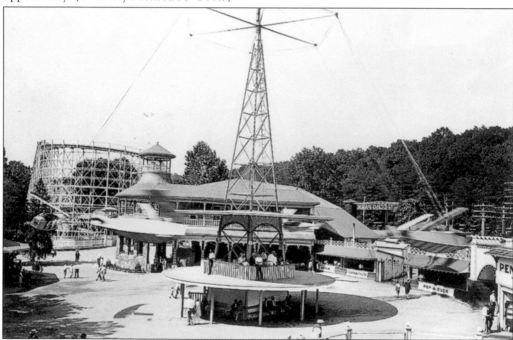

AIRPLANES. The Airplanes served as the park's central focus for many years, the ride's tower clearly visible from the main entrance and beyond. In this 1920s view, the planes keep pace with the Coaster Dips to the upper left and hover over the Whip at the bottom right, as well as Pennyland arcade and a row of amusement games. (Courtesy Richard A. Cook.)

34

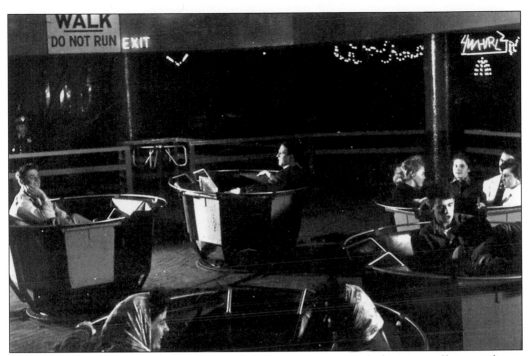

TEACUPS. Glen Echo also boasted one of these amusement park favorites, offering riders a whole new way to make themselves dizzy. (Courtesy Richard A. Cook.)

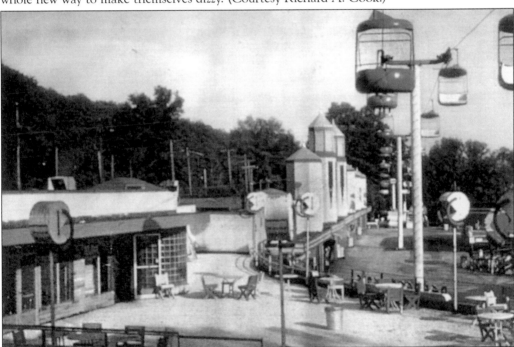

ALPINE HI-RISE. This view from the park's final season in 1968 shows the Alpine Hi-Rise, a sky bucket attraction popular at amusement parks throughout the nation at that time. This is much the way the park appeared during its last gleam of national fame, when it was used as a backdrop for filming during an episode of the CBS television series *Gomer Pyle, USMC* in 1967.

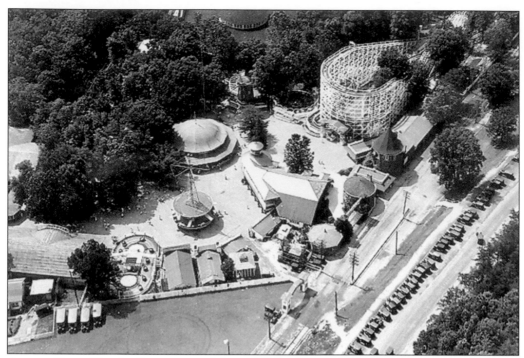

AERIAL VIEW. This bird's-eye view of the park offers an idea of Glen Echo's layout. (Courtesy Richard A. Cook.)

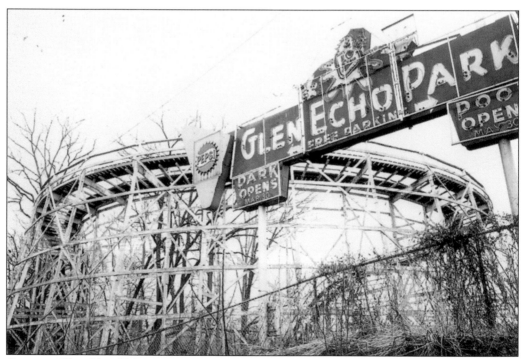

CLOSED. The Glen Echo sign remained for several years following the park's final season, reminding passersby of what once had been. (Courtesy Richard A. Cook.)

Three

WASHINGTON AREA PARKS

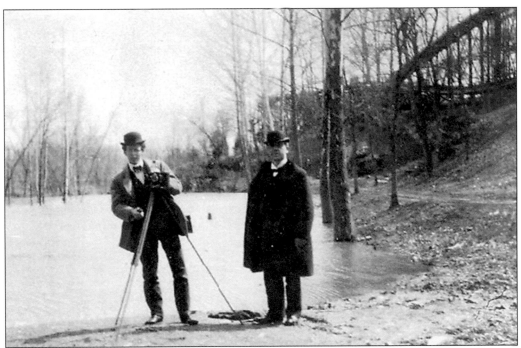

CABIN JOHN PARK. Built as part of the Cabin John Hotel resort in Montgomery County in 1876, Cabin John Park is one of the lesser-known amusement parks in Maryland. Operating sporadically through 1910, the park saw only limited success yet holds an important place in amusement park history as an early testing ground for companies that became two of the biggest names in the business: L.A. Thompson and Gustav Dentzel. In this photo, a surveyor stands in front of the park's roller coaster supports, seen at right. (Courtesy Richard A. Cook.)

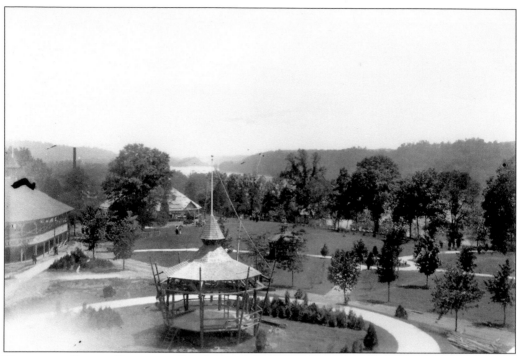

THOMPSON SCENIC RAILWAY. The focus of this photo of Cabin John Park is the bandstand in the center, but the historic value lies in the building to the left. It housed one of the first L.A. Thompson Scenic Railway rides that took the American amusement industry by storm following its unveiling in Atlantic City, New Jersey, in 1887. (Courtesy Richard A. Cook.)

DENTZEL CAROUSEL. This photo's focus again is on the bandstand in the center, but of more importance is the carousel building in the background at the left. Also seen in the photo above, the building housed what is believed to have been the second or third carousel carved by amusement industry pioneer Gustav Dentzel. (Courtesy Richard A. Cook.)

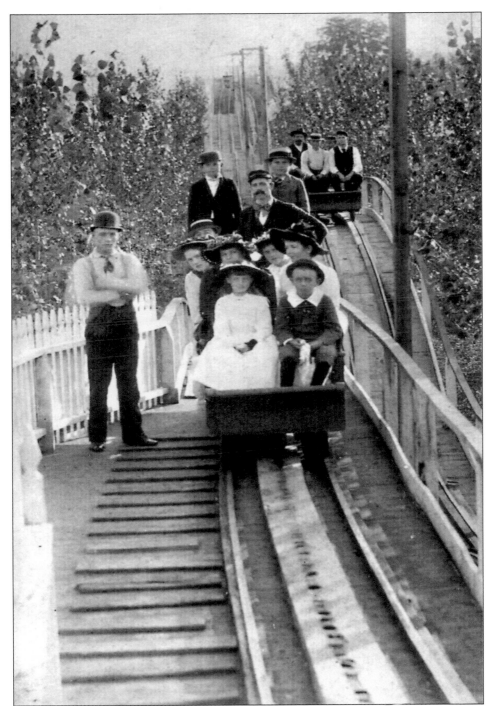

RIVER VIEW ON THE POTOMAC. A turn-of-the-century amusement park in Prince George's County, River View Park on the Potomac was operated by the Randall family as a destination for its steamboat line. The park offered both relaxation and thrills, the latter evidenced by this early roller coaster, c. 1900. (Courtesy Maryland State Archives Special Collections, Robert G. Merrick Archives of Maryland Historical Photographs, MSA SC 1477-1-6158.)

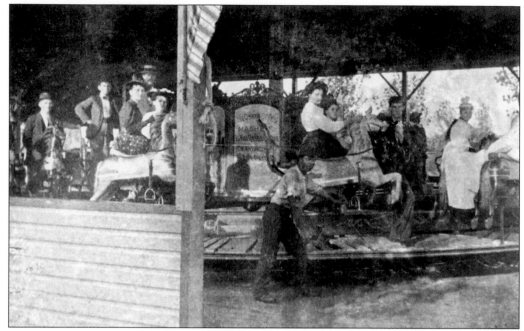

CAROUSEL. The carousel, seen c. 1900, was the centerpiece of River View on the Potomac in Prince George's County. In later years, a used steamboat engine powered the ride. River View served the area around Hatton Point from about 1895 to roughly 1918. (Courtesy Maryland State Archives Special Collections, Robert G. Merrick Archives of Maryland Historical Photographs, MSA SC 1477-1-6160.)

ANIMAL CARTS. Goats and donkeys powered these carts for young children at River View. The cart path took riders past the carousel. (Courtesy Maryland State Archives Special Collections, Robert G. Merrick Archives of Maryland Historical Photographs, MSA SC 1477-1-6161.)

BOWLING ALLEY. One of the park's unique features was its open-air bowling alley, seen here c. 1900. (Courtesy Maryland State Archives Special Collections, Robert G. Merrick Archives of Maryland Historical Photographs, MSA SC 1477-1-6159.)

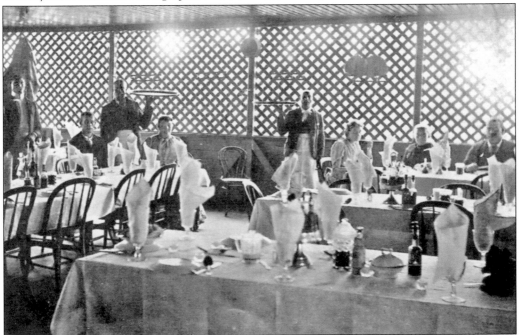

DINING ROOM. An open-air dining room made sure patrons were not hungry while they enjoyed River View's activities. Despite the room's outdoors nature, meals served here were traditionally formal. (Courtesy Maryland State Archives Special Collections, Robert G. Merrick Archives of Maryland Historical Photographs, MSA SC 1477-1-6163.)

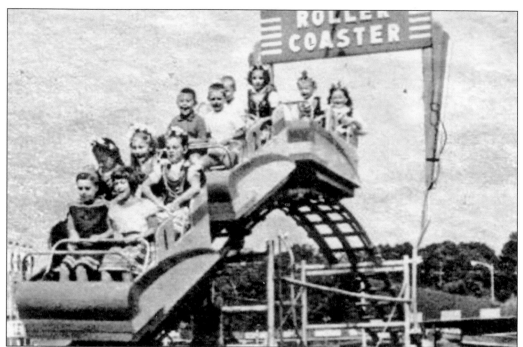

KIDDIELAND. Located in Montgomery County's Takoma Park, Kiddieland operated in the 1950s and was one of the first amusement parks in Maryland to cater exclusively to children.

ADVENTURE WORLD. This park was established in Largo in Prince George's County in 1982 as the Wild World water park. By 1986, the park's focus had shifted from strictly water rides to more traditional amusement park fare. In 1993, the park's name changed to Adventure World. Two years later in 1995, the suspended looping coaster Mind Eraser, seen here, was installed. (Courtesy Sara Cox.)

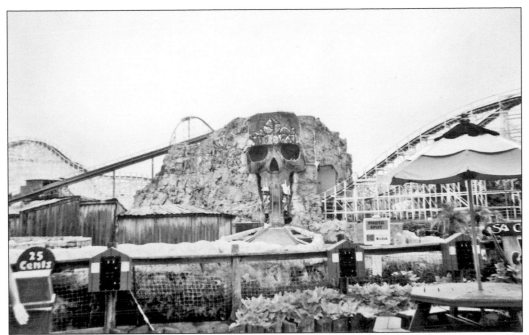

SIX FLAGS AMERICA. In 1998, theme park giant Six Flags Inc. purchased Adventure World's parent company, Premier Parks, and opened the park the next year as Six Flags America. Themed areas at the time of the name change included Skull Island, seen here. (Courtesy Sara Cox.)

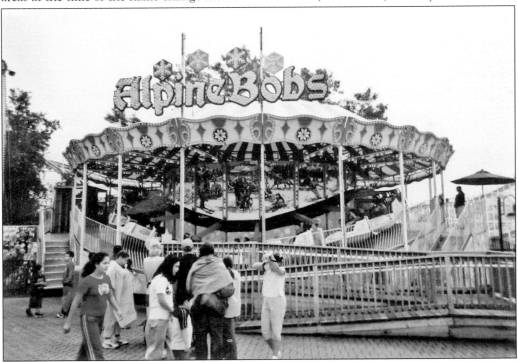

ALPINE BOBS. A modern version of a popular ride, the Alpine Bobs exemplifies the mixture of smaller, yet still thrilling, rides scattered through the park alongside Six Flags's trademark roller coasters. (Courtesy Sara Cox.)

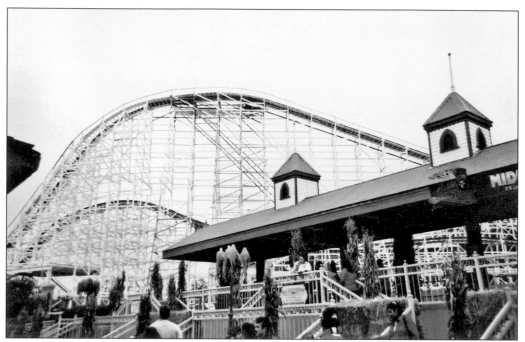

WILD ONE. Designed by John Miller in 1917, the Wild One coaster is the most historic ride at the Six Flags park. Rebuilt by Herb Schmeck in 1932 after being damaged by fire, the ride originated as the Giant Coaster at Massachusetts's Paragon Park. Wild World acquired the coaster following Paragon's closing in 1985 and hired the Dinn Corporation to rebuild the ride at its current location. (Courtesy Sara Cox.)

OCTOPUS. A literal translation of the carnival favorite led to both the theme and thrills of this ride. (Courtesy Sara Cox.)

Four

BALTIMORE AREA PARKS

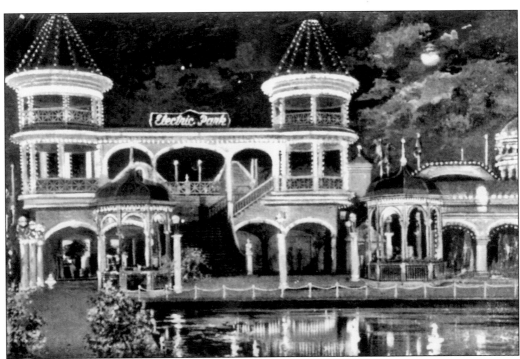

ELECTRIC PARK AT NIGHT. The main attraction at this park, opened in the 1890s, was not its rides, per se, but its lights. Electricity was still a novelty in the late 19th century, and thousands visited Electric Park to see the hundreds of lights that lined its buildings and reflected off the waterfront on Belvedere Avenue near Reisterstown Road. The park was demolished in 1916.

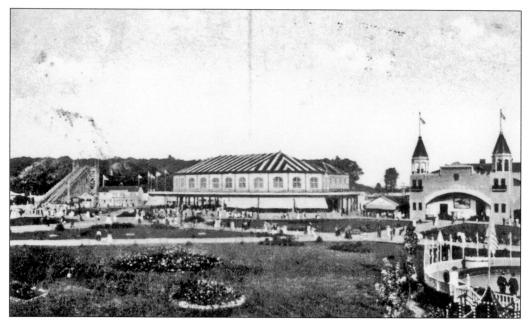

AERIAL VIEW OF ELECTRIC PARK. Electric Park's interior was almost as splendid as its exterior. Attractions pictured from left in this 1910 view include the carousel, Shoot the Chute, and Johnstown Flood, in which a re-creation of the infamous 1889 storm destroyed a miniature version of the Pennsylvania town. At the bottom right is the Electric Park horse track, where harness racing attracted almost as much attention as the park's electrified facade.

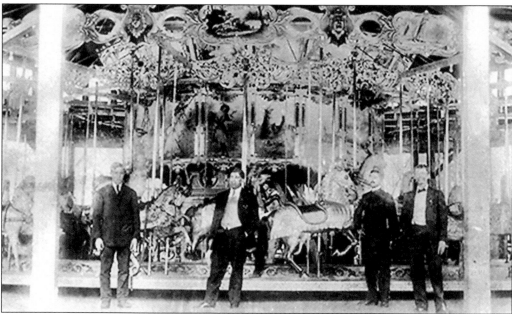

CAROUSEL. The Electric Park carousel, seen here in 1901, was a mainstay at the park. Other attractions included a roller coaster, Ferris wheel, Human Roulette Wheel, movie theater, touring vaudeville shows, Pawnee Bill's Wild West show, and a fireworks display conducted by a man using the pseudonym "Professor Pain." On special occasions, a band led by Signor Vincent Del Manto played the "Electric Park March" on the deck atop the park's main entrance.

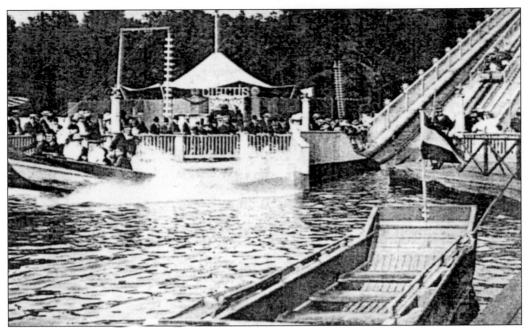

SHOOT THE CHUTE. One of Electric Park's signature attractions was the 150-foot Shoot the Chute, piloted by a crew of eight men nicknamed "Bluejackets" for their uniforms. Perhaps the only attraction that rose higher above the grounds was a dirigible, launched from the park in 1908 as a publicity stunt, that became the first such craft to fly over Baltimore City.

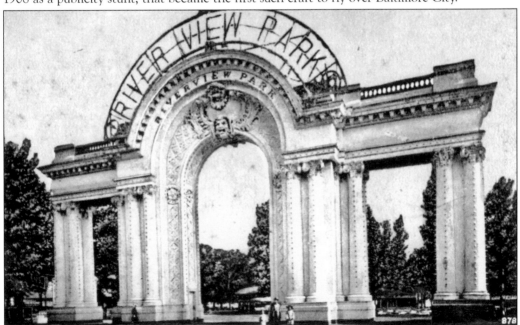

RIVERVIEW PARK. The grand entrance to Riverview Park gave patrons an idea of the elegance they could expect inside. Founded in 1890, Riverview grew into one of Baltimore's most popular parks. Founded by the Riverview Nanatorium and Amusement Company at Point Breeze, the park was later owned by the United Railways and Electric Company and operated as a trolley park, billed as "the Coney Island of the South."

BANDSTAND. Uniformed men lined up on the Riverview bandstand stage for this photo, taken in 1922 for the *Baltimore News American* newspaper. While concerts at the bandstand were integral to the park's entertainment offerings, other exhibitions throughout the park included parachute jumps, balloon ascensions, beauty contests, boxing matches, and an annual "Battle of the Alamo" fireworks display.

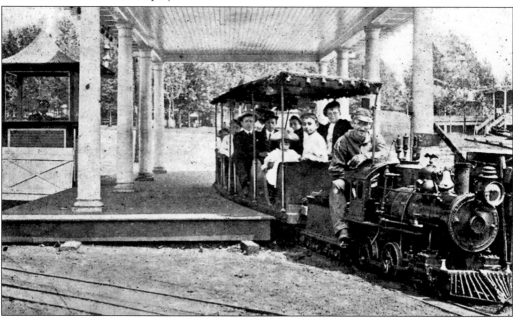

MINIATURE RAILWAY. This 1908 view shows the Riverview Park as families saw it during the day. However, according to a 1904 editorial from the *Baltimore Sunday Herald*, Riverview actually drew two types of crowds: the daytime family crowd and the teenagers who came out at night to dance. While the editorial took no side in the matter, it stressed that the two factions did not mix.

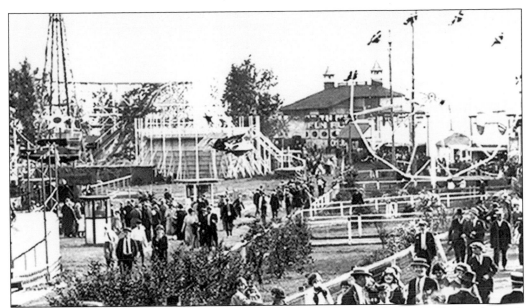

INSIDE RIVERVIEW. A look at the interior of Riverview Park shows the types of rides the park offered. Attractions found at various times within its boundaries until it closed in 1929 were the Coal Mine Dips racing coaster, the Ben-Hur switchback coaster, a "Crossing the Alps" Scenic Railway, a Human Roulette Wheel, an Aero Swing, two swimming pools, a dance hall, sideshows, and several fun houses including Katzenjammer Castle and Ye Ould Mill.

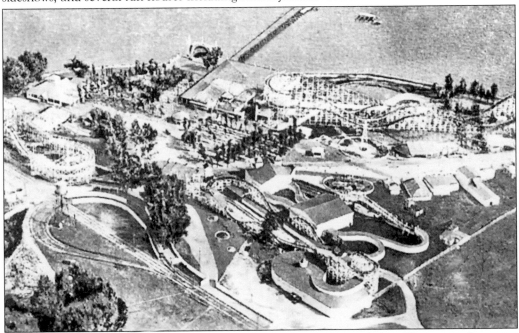

AERIAL VIEW. This 1926 view shows the three roller coasters that inhabited Riverview during its waning years. While fire ravaged the park nearly a half dozen times during its 39-year existence, development tolled its death knell. The grounds were sold at auction in 1929 to make way for a Western Electric plant. When the Great Depression hit just months later, it looked like United Railways received the better end of the bargain. (Courtesy Baltimore Streetcar Museum.)

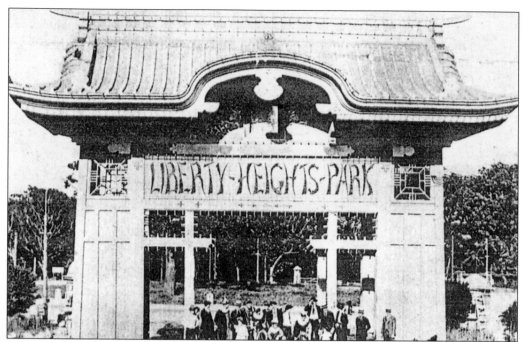

LIBERTY HEIGHTS PARK. Opened in 1919, Liberty Heights Park was arguably the crown jewel of Baltimore's amusement parks. Within two years of its opening at Park Circle, owner John Carlin sought a shorter, easier-to-remember name for the establishment, and the establishment was re-named Carlin's Park. The Japanese influence seen on the entryway continued on buildings inside, including the popular Dance Palace, built in 1920.

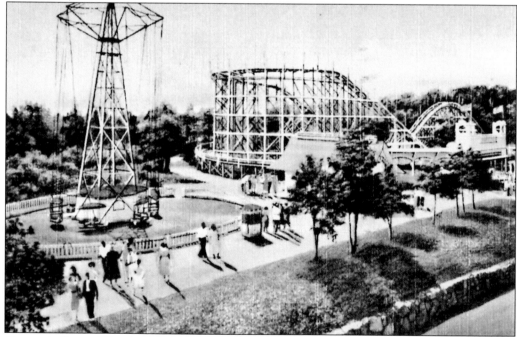

CARLIN'S PARK. The Aero Swing, Mountain Speedway roller coaster, and main entrance are visible in this bird's-eye view of the park, *c.* 1947.

THE MOUNTAIN SPEEDWAY. Called simply "Speedway" by the time this photo was taken in 1941, this was the top attraction at Carlin's Park from the ride's opening in 1920 to the park's closing in 1955. Along with dips and curves, it featured an 800-foot tunnel. (Courtesy Maryland Historical Society, B 348(2)GG.)

THE AERO SWING. This was a popular attraction at Carlin's Park when this photo was taken in 1938. However, the excitement was minimal compared to 15 years earlier in 1923 when the park's most famous visitor, Rudolph Valentino, emerged from the Dance Palace nearly shirtless after being mobbed by young female fans. Valentino was judging a dance contest at the park. (Courtesy Maryland Historical Society, B 348(1)D.)

THE WHIP. This attraction took Carlin's patrons on a fast ride, as seen in this 1941 photo. (Courtesy Maryland Historical Society, B 348(2)K.)

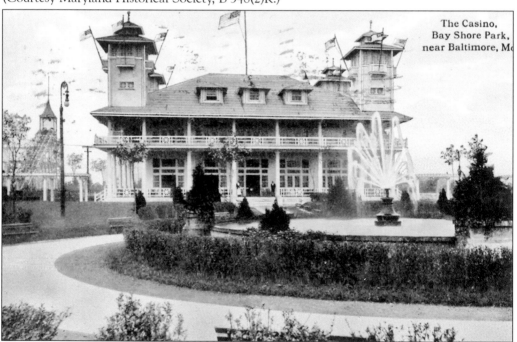

The Casino,
Bay Shore Park,
near Baltimore, Md

BAY SHORE PARK. Built as a trolley park in 1906 by the United Railways and Electric Company, Bay Shore was another of Baltimore's most popular parks. While patrons enjoyed its rides and amusements, one of its biggest attractions was the giant fountain that served as the park's centerpiece. Here, it is seen in front of the park's restaurant and multi-purpose building, the Casino. To the left is the Wild Cat wooden roller coaster, added in 1907.

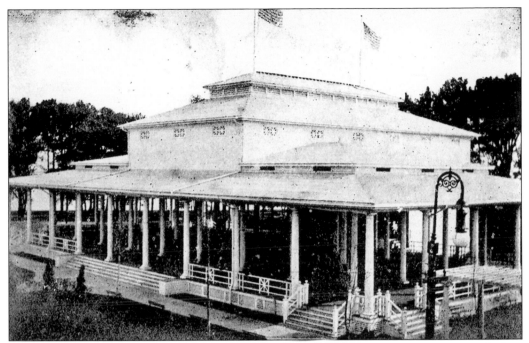

BANDSTAND. Seen here in 1907, Bay Shore's bandstand hosted many music groups, including the Royal Artillery Band, led by Guiseppe Aiala. On opening day, August 11, 1906, that band performed two pieces written especially for the occasion: "Bay Shore Park" and "United Railways and Electric Company."

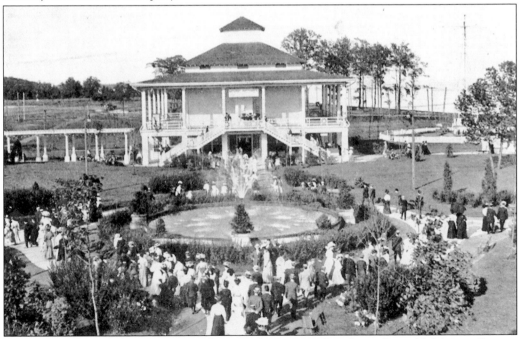

MOVING PICTURE PAVILION. Facing the main fountain and gardens, the park's Moving Picture Pavilion provided entertainment and a few moments in the shade, away from the summer sun. At right is the support tower for the Aero Swing.

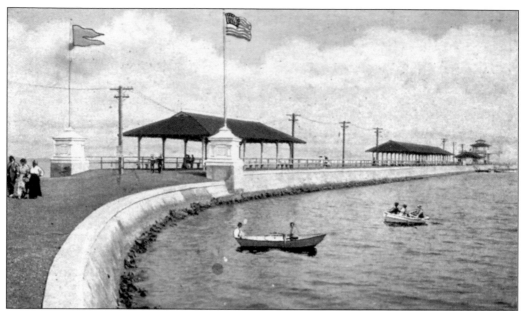

CRYSTAL PIER. The 1,000-foot Crystal Pier gave Bay Shore patrons a chance to stroll along the water without taking the chance of getting their feet wet. By 1944, the pier and the rest of the park belonged to entrepreneur George Mahoney, who had leased the facilities since 1939. He bought the establishment from the Baltimore Transit Company, formerly United Railways, in 1944.

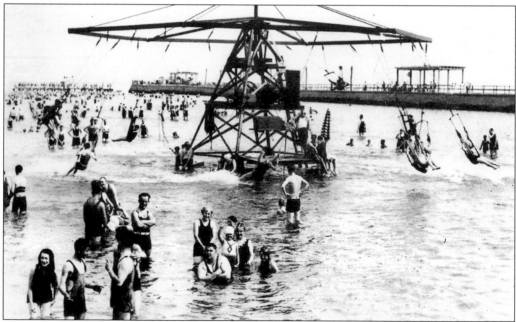

SEA SWING. A location adjacent to the Chesapeake Bay gave Bay Shore operators the chance to offer their patrons rides other parks could not. Some, including the Sea Swing, proved too risky for insurance companies. The swing was removed after several years because of liability issues. (Courtesy University of Maryland Libraries Division of Collection Management and Special Collections.)

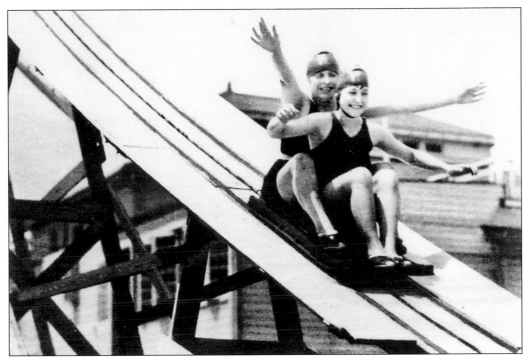

ORIGINAL WATER SLIDE. One ride that remained at the park for many years was the water slide from the beach into the Chesapeake. Riders on this version rode down a dry slide atop a sled that ran in slots on the board. (Courtesy University of Maryland Libraries Division of Collection Management and Special Collections.)

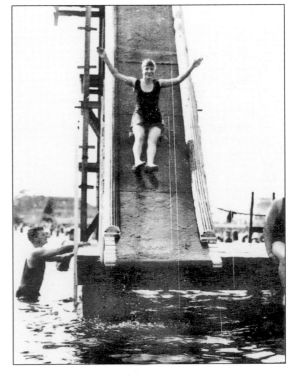

NEW WATER SLIDE. A newer model of the slide, introduced in the park's later years on the nearby bathing pier, added a stream of flowing water down the board, eliminating the need for the slots. While not as long as the original slide, it proved just as popular with park patrons. (Courtesy University of Maryland Libraries Division of Collection Management and Special Collections.)

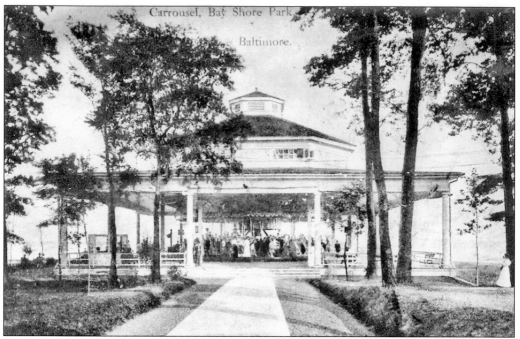

CAROUSEL. Bay Shore's carousel was another popular attraction, operating until the park's final season.

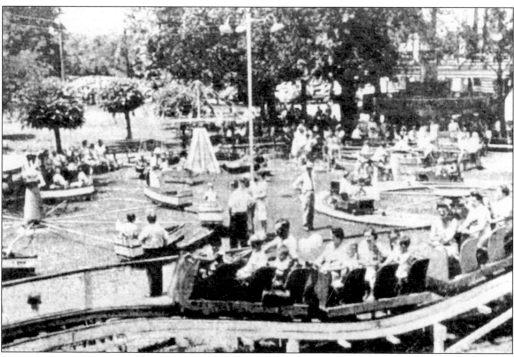

KIDDIE LAND. The children's area, added in the park's waning years, included the Kiddie Koaster, General Douglas MacArthur Railroad, a whip, and rail rides dedicated to boats and Jeeps. For the adults, new attractions nearby included a fun house. All were demolished or removed following the park's sale to the Bethlehem Steel Corporation in 1947.

THE SPEEDWAY. One of two roller coasters to inhabit Bay Shore Park, the Speedway was introduced during George Mahoney's days at the park. In this view, the trolley station that brought many guests to the park is visible through the coaster's supports. (Courtesy Baltimore Streetcar Museum.)

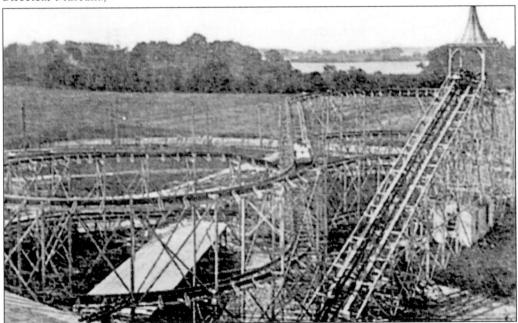

THE WILD CAT. The park's other coaster, the Wild Cat, was built in 1907 and provided thrills to patrons through most of the park's history. A thin wooden mock-up of the Wild Cat car's side allowed guests to have their pictures taken while appearing to ride the coaster during the park's early days.

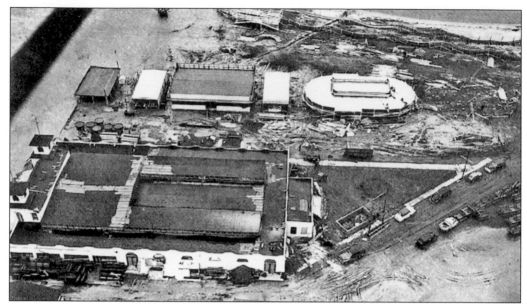

BAY ISLAND BEACH. Following Bay Shore's demise, George Mahoney assumed a new bayside amusement park would attract visitors. He constructed a new resort on nearby Pleasure Island that opened in 1948. Besides the beach, the park's main attractions included a roller coaster and small midway, both of which closed in 1958. Mahoney sold the park in 1960. Its new owner closed the park and sold the land to Bethlehem Steel in 1964.

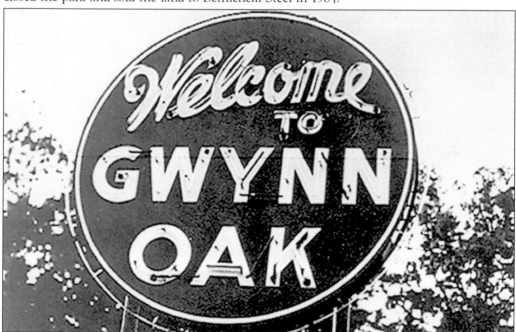

GWYNN OAK PARK. Opened in Woodlawn in 1893, Baltimore's longest-running amusement park stayed in business until foreclosure shut its doors in 1973. Owners attributed the park's financial difficulties to damage from 1972's Tropical Storm Agnes and controversy surrounding the park's equal accommodation policy, enacted in 1963. Here, the Gwynn Oak sign is seen in the early 1940s.

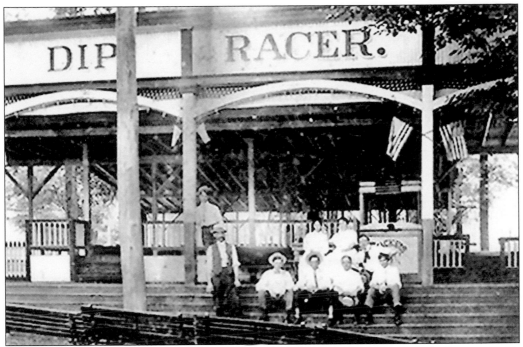

DIP RACER ENTRANCE. Seen c. 1905, the entrance to the Dip Racer led to Gwynn Oak's wooden racing coaster, a ride few amusement parks were without in the early 20th century.

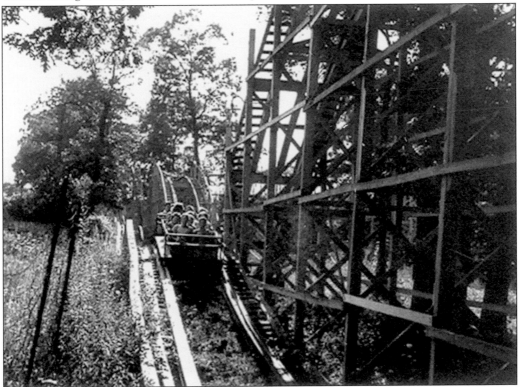

DIP RACER. This view shows the layout of the Dip Racer as it appeared in the early 1940s.

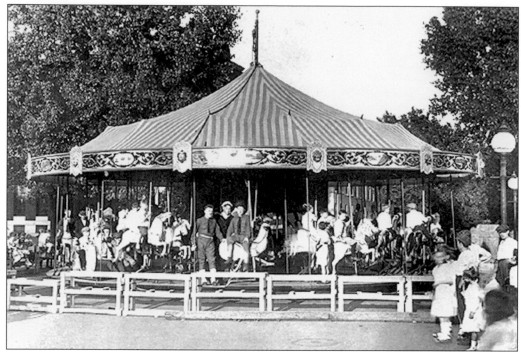

CAROUSEL. Gwynn Oak's earliest carousel, seen here in 1911, was created by the Artistik Carousell Manufacturing Company.

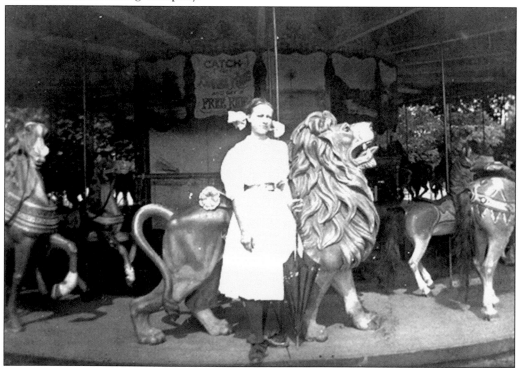

RIDING THE CAROUSEL. This view, c. 1910, offers a closer look at one of the carousel's animals, a carved lion.

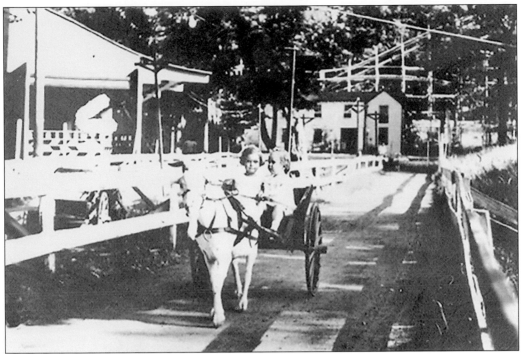

GOAT CARTS. As at other parks, not all of Gwynn Oak's attractions were man-made, as this 1940s goat cart ride shows.

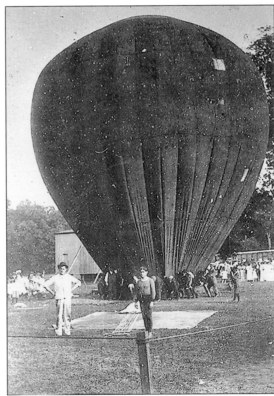

BALLOON ASCENSION. Crowds gathered to watch this hot air balloon ascension at Gwynn Oak in 1906. Such feats were popular at many of Baltimore's parks in the early 20th century.

LADIES' AND GENTS' RIFLE PRACTICE. This shooting gallery, c. 1905, encouraged both men and women to try their luck.

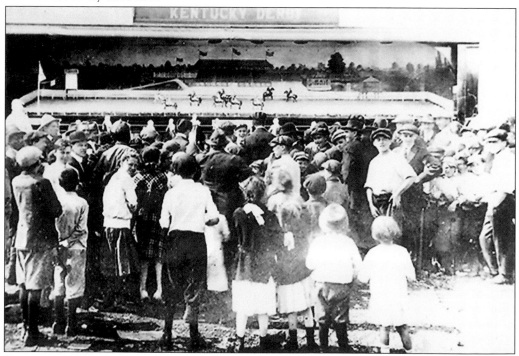

KENTUCKY DERBY. A staple at amusement parks throughout the United States, this game drew considerable interest among not only players, but also among spectators during its reign at Gwynn Oak Park.

PIKE'S PEAK. "Ride the Great Pike's Peak Route or Bust," declared the sign at the Scenic Railway near Gwynn Oak's entrance in the early 1900s.

AERO SWING. This ride, featuring miniature airplanes, was popular at Gwynn Oak as well as other area parks in 1910.

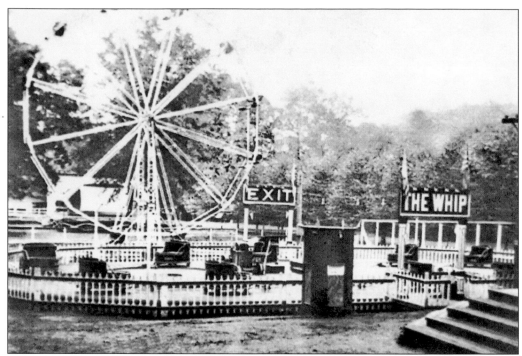

FERRIS WHEEL AND WHIP. These Gwynn Oak mainstays were located near the main gate in 1968. (Photo by Fred G. Kraft Jr., *Baltimore News American*.)

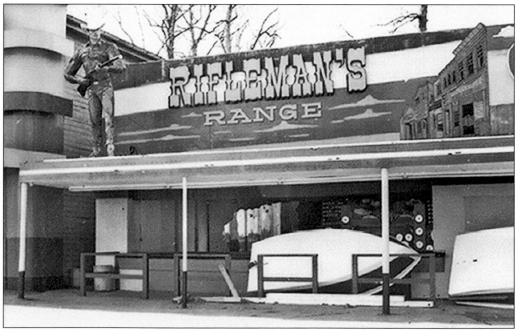

RIFLEMAN'S RANGE. A modern version of the Ladies' and Gents' Rifle Practice, the Rifleman's Range served Gwynn Oak in later years. Seen here is the 1968 shooting gallery. (Photo by Fred G. Kraft Jr., *Baltimore News American*.)

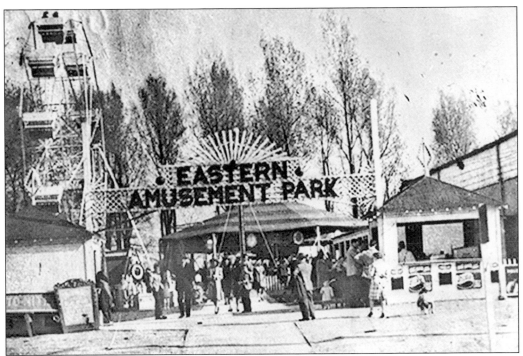

EASTERN AMUSEMENT PARK. Located on Eastern Avenue, this park drew a large crowd when this photo was taken around the 1930s.

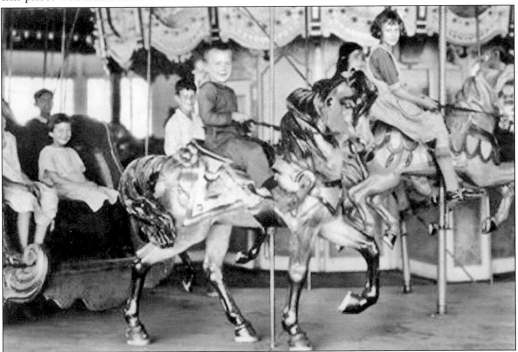

FREDERICK ROAD PARK. Opened in 1920, this park featured the 52nd carousel made by the Philadelphia Toboggan Company, seen here. The park also included a John Miller–designed roller coaster, the Deep Dipper.

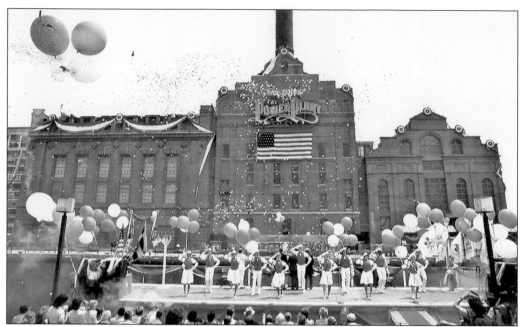

OPENING DAY AT THE POWER PLANT. Opened in 1985 in Baltimore's Inner Harbor, Six Flags's Power Plant was Maryland's second theme park, following The Enchanted Forest 30 years earlier. Devoid of rides, the Power Plant focused more on hands-on activities as guests explored the laboratory of the late Dr. Phinneas T. Flagg, an eccentric inventor who attempted to build an energy source large enough to power the world. (Courtesy Taylor Jeffs.)

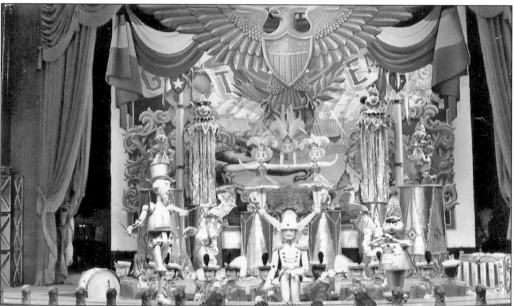

INSIDE THE POWER PLANT. Dr. Flagg's inventions, including this over-sized music box, entertained patrons until the park's closing in 1989. Following a failed attempt to maintain a dance club in the building the next year, the structure remained vacant until 1997 when developers re-engineered the space as a dining and retail facility. The building still retains the Power Plant name as a reminder of its earlier days. (Courtesy Taylor Jeffs.)

Five

THE ENCHANTED FOREST

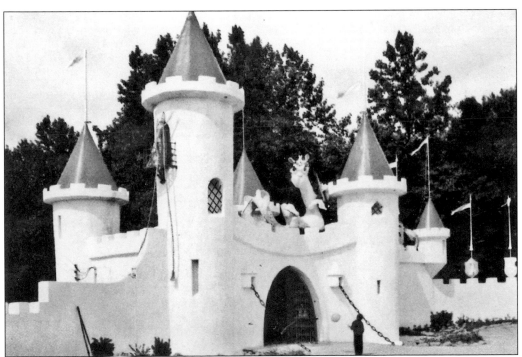

THE ENCHANTED CASTLE. This site has welcomed drivers on U.S. 40 in Ellicott City since 1955 as the main entrance to The Enchanted Forest. During the park's original operation, children could speak with Rapunzel in the left-hand tower using a telephone on the side of the building as the Wise Old Dragon kept watch from above. The castle is one of the only portions of the park maintained since its initial closing in 1988.

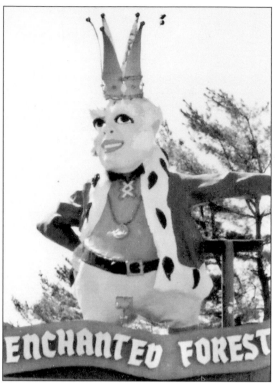

OLD KING COLE. Besides the Enchanted Castle and Wise Old Dragon, Old King Cole is the only other figure from The Enchanted Forest that has been constantly maintained since 1955. During the park's operation, he pointed visitors toward its parking lot. He now serves as an eye-catcher for the shopping center that sits on the former Enchanted Forest site in Howard County.

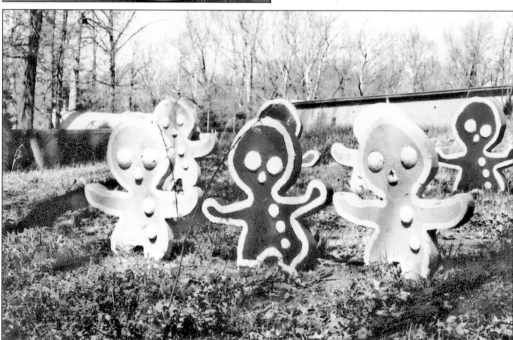

GINGERBREAD MEN. The Enchanted Forest's iconic brown and pink gingerbread men greeted park patrons for nearly 40 years until seeing their last official visitors when the park briefly re-opened for the 1994 season. They, along with many of the park's other surviving figures, moved to a new home nearby at Clark's Elioak Farm in 2005.

68

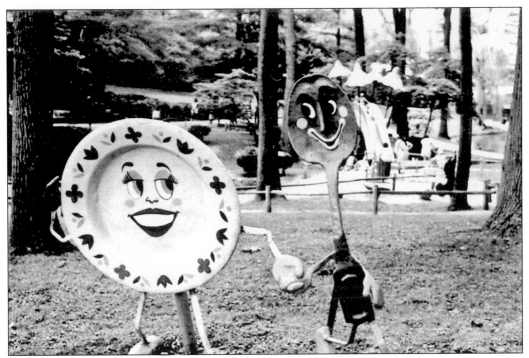

DISH AND SPOON. This exhibit, a park staple since opening day, allowed children to see exactly where the dish went when it ran away with the spoon in the classic nursery rhyme "Hey Diddle Diddle." (Courtesy Monica McNew-Metzger.)

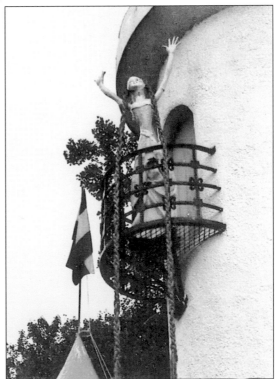

RAPUNZEL. From the turret of the Enchanted Castle, the long-haired Rapunzel spoke to children via the telephone far below her window. (Courtesy Monica McNew-Metzger.)

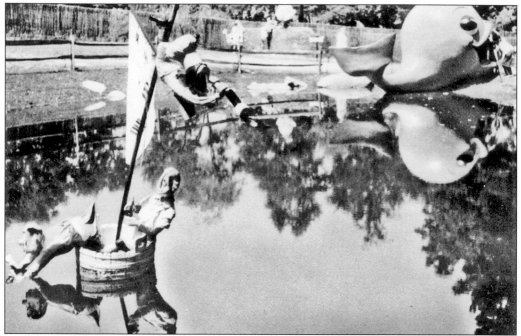

THREE MEN IN A TUB AND WILLIE THE WHALE. While the Three Men in a Tub display adhered to the park's nursery rhyme traditions, Willie the Whale took on a more biblical tone. Children climbing into his mouth could not only hear him laugh, but also could see the swallowed fisherman Jonah. Along with the gingerbread men and the Wise Old Dragon, Willie was one of the park's most iconic figures.

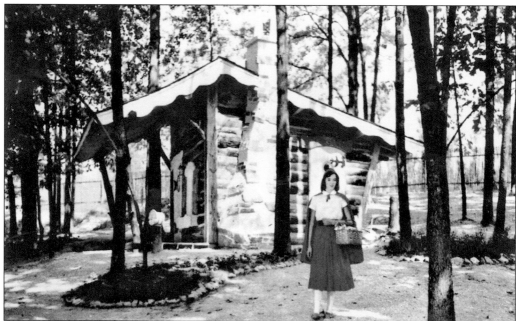

LITTLE RED RIDING HOOD. During the park's early days, costumed characters roamed the grounds. As seen here, the actress portraying Little Red Riding Hood never strayed far from her grandmother's house.

70

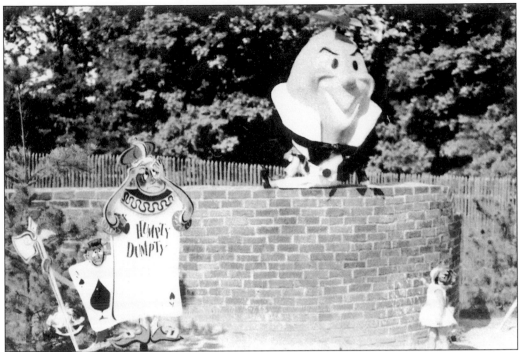

HUMPTY DUMPTY. Humpty Dumpty never fell from his wall at The Enchanted Forest, though the children who saw him knew it was inevitable. Playing cards from *Alice in Wonderland* told his story.

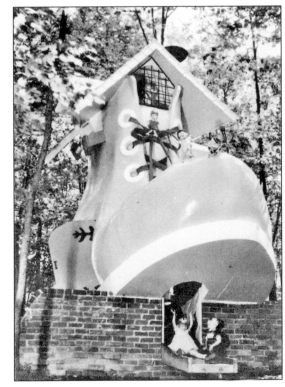

OLD WOMAN IN THE SHOE. Contrary to the nursery rhyme's verses, no one actually lived in The Enchanted Forest's shoe, so children were free to enjoy the sliding board inside.

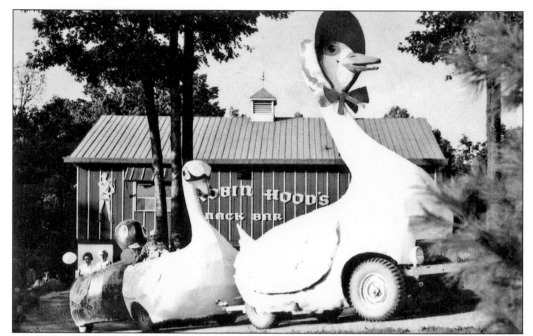

MOTHER GOOSE AND ROBIN HOOD'S BARN. A team of fairy tale fowl headed by Mother Goose and ending with the Ugly Duckling transported families around the park. The menagerie is seen here in front of Robin Hood's Barn, the park's snack bar and gift shop. The barn's lower level served as the site of the Chicken Little Trio show in later years. (Courtesy Carol Brewington Smith.)

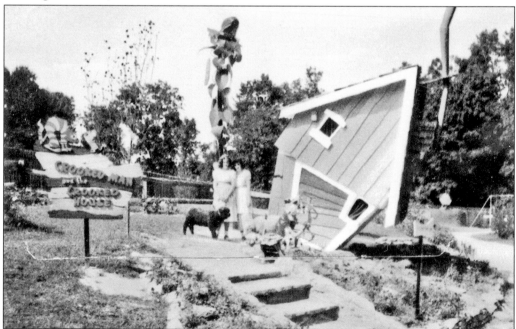

THE CROOKED OLD HOUSE. The Crooked Old Man, his Crooked Old Cat, and the Crooked Old Mouse all lived in the Crooked Old House, awaiting visits from the park's younger patrons. The beanstalk of *Jack in the Beanstalk* fame is seen in the background.

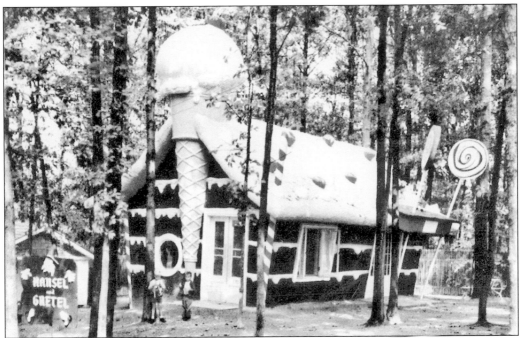

HANSEL AND GRETEL'S HOUSE. During the park's early days, the candy house in which Hansel and Gretel met the witch was open for all to explore. In later years, the house was reserved for birthday parties. The peppermint-stick jail inside remained a favorite with children.

THE THREE BEARS' HOUSE. The Three Bears' House of Goldilocks fame was another popular attraction open throughout The Enchanted Forest's history. Inside, children got to see which porridge was too hot and which was too cold. Behind the house, they could have their photos taken with Papa Bear.

MERRY MILLER'S HOUSE. The Merry Miller and his Happy Mouse Band resided at the park throughout its existence.

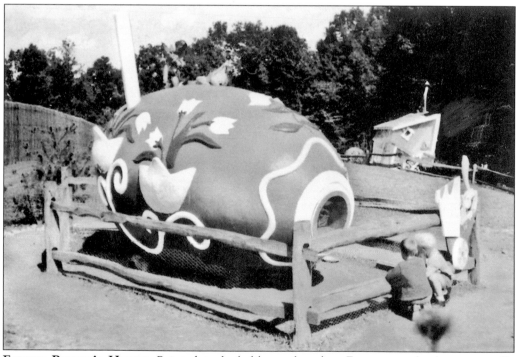

EASTER BUNNY'S HOUSE. Painted to look like a chocolate Easter egg, the house actually concealed a hutch containing live rabbits.

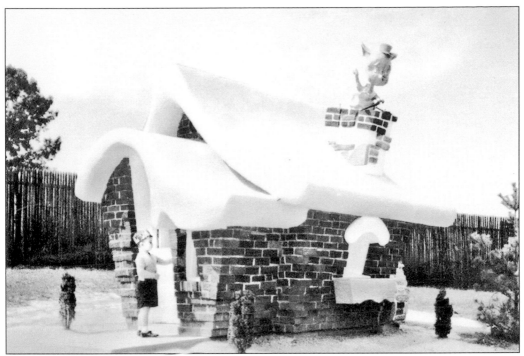

THREE LITTLE PIGS. Children were invited to peek inside the brick house not even the Big Bad Wolf could penetrate.

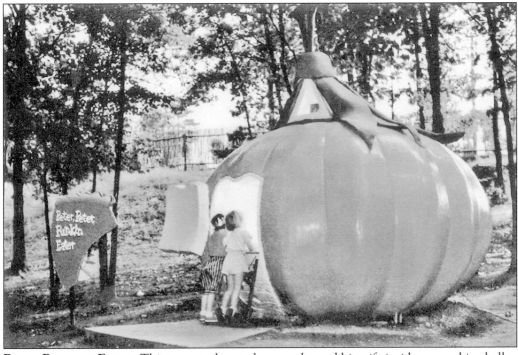

PETER PUMPKIN EATER. This nursery rhyme character housed his wife inside a pumpkin shell.

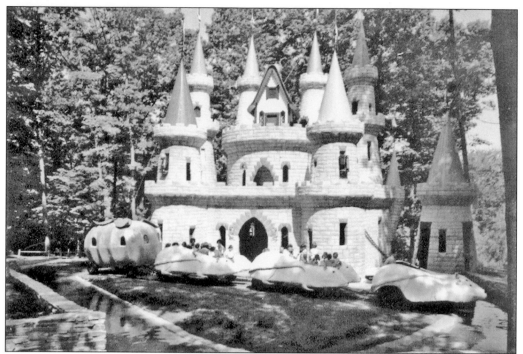

CINDERELLA'S CASTLE. Those who wanted to visit Cinderella's Castle had to take the Pumpkin Coach, seen at left, pulled by white mice across the castle's moat. In later years, the mice were transformed into picnic benches and a cheese-themed sliding board.

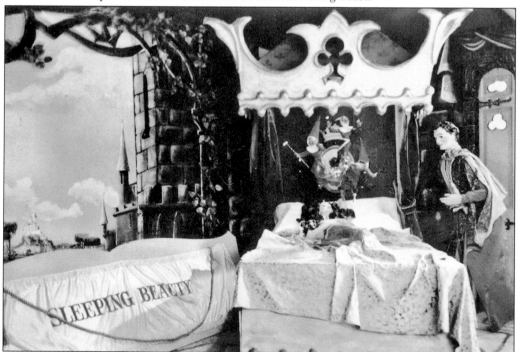

SLEEPING BEAUTY. Children were able to see dioramas representing the Sleeping Beauty story following the park's 34-acre expansion in the early 1960s.

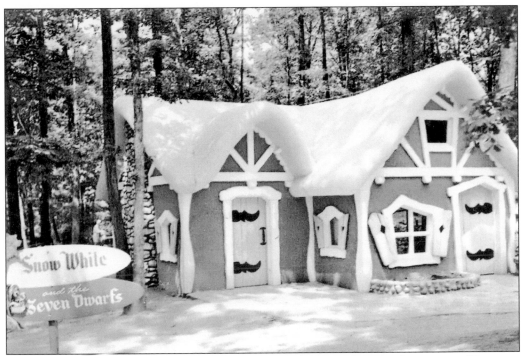

SNOW WHITE'S HOUSE. The Seven Dwarfs' cottage led to an underground gem mine. (Courtesy Carol Brewington Smith.)

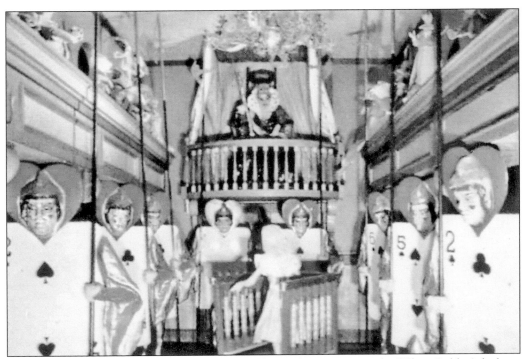

ALICE IN WONDERLAND. A teacup-shaped trolley took visitors into the White Rabbit's hole to see Alice's adventures through a series of dioramas.

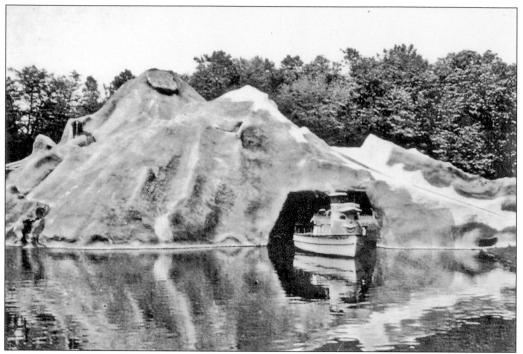

LITTLE TOOT AND MT. VESUVIUS. In one of the park's most adventurous attractions, slides took visitors down one side of Mt. Vesuvius while Little Toot made voyages through the tunnel on the other side. The Enchanted Forest brought this storybook and cartoon tugboat to life.

LITTLE RED SCHOOLHOUSE. An elderly schoolmarm watched over the entrance to this attraction, ironically appealing to children even on weekends and during the summer. (Courtesy Carol Brewington Smith.)

ANTIQUE CARS. Another addition to the park in the 1960s, these cars allowed children to practice their driving at an early age.

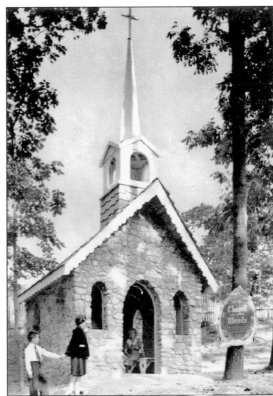

CHAPEL IN THE WOODS. One of only two amusement park–based church structures in Maryland and the only one outside Ocean City's Frontier Town, the Chapel in the Woods offered Enchanted Forest patrons a quiet place to reflect.

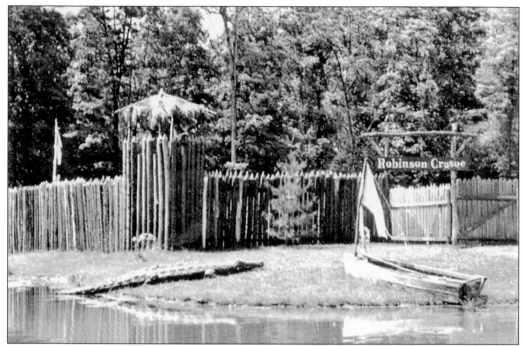

ROBINSON CRUSOE ISLAND. Rafts took children to the island where they could visit the lookout tower, feed live goats, and burn off steam in the open area.

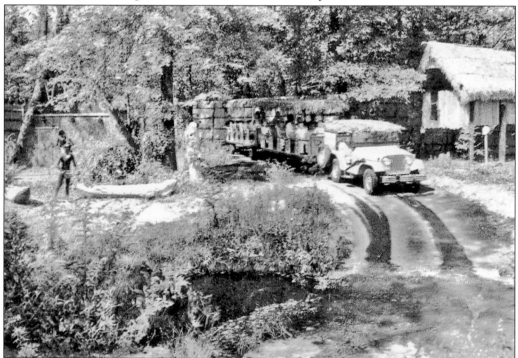

SAFARI RIDE TO JUNGLELAND. Accounting for a large part of the 1960s expansion, the Safari Ride to Jungleland took visitors on a land-based journey reminiscent of Disneyland's popular Jungle Cruise attraction. (Courtesy Carol Brewington Smith.)

Six

SOUTHERN MARYLAND PARKS

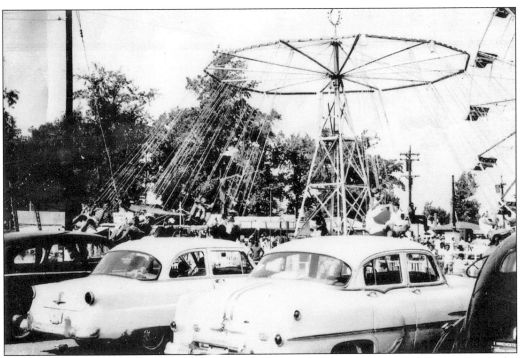

CARR'S BEACH. Established in the 1950s, Carr's Beach in Anne Arundel County was the African-American community's answer to the segregated beach resorts of Southern Maryland and the Eastern Shore. The swings of Carr's Beach Amusement Park are seen over the resort's parking lot in this 1958 view. (Courtesy Maryland State Archives, The Annapolis I Remember Collection, MSA SC 2140-1-157.)

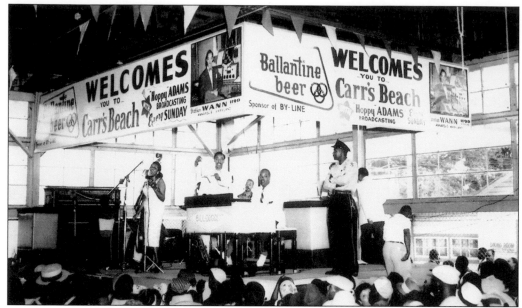

DANCE PAVILION. By far the biggest attraction at Carr's Beach was its dance pavilion, which drew some of the top names in show business. Celebrities from Chuck Berry to Ella Fitzgerald performed on the pavilion's stage nearly every weekend through the beach's final days in the early 1970s. Here, pianist Bill Doggett shares the stage with WANN radio personality Hoppy Adams (center) in 1956. (Courtesy Maryland State Archives, The Annapolis I Remember Collection, MSA SC 2140-1-153.)

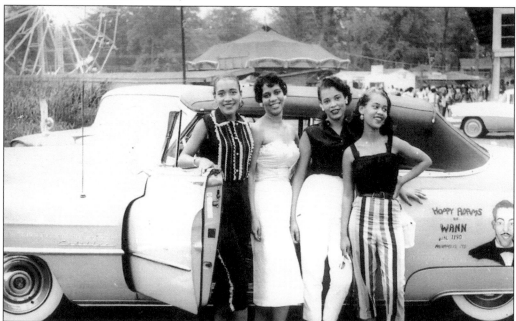

FERRIS WHEEL. The rides at Carr's Beach Amusement Park were some of the biggest attractions for children visiting the resort. The park's Ferris wheel and carousel are seen over Hoppy Adams's car in this 1956 photo. (Courtesy Maryland State Archives, The Annapolis I Remember Collection, MSA SC 2140-1-155.)

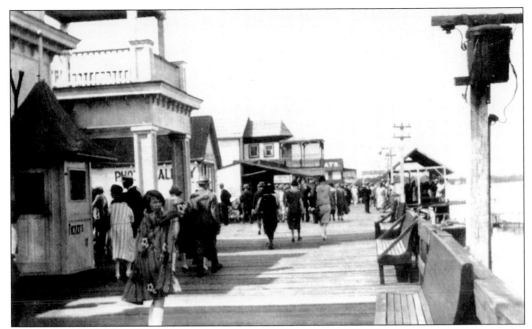

CHESAPEAKE BEACH. In the early 20th century, Chesapeake Beach was one of the most popular day trip destinations for those seeking some time away from the big-city life of Baltimore and Washington. Located in Calvert County, the area saw daily service from the Chesapeake Beach Railway Company and several steamboat lines. The early boardwalk is seen in this view near the entrance to the town's signature roller coaster, the Great Derby. (Courtesy Chesapeake Beach Railway Museum.)

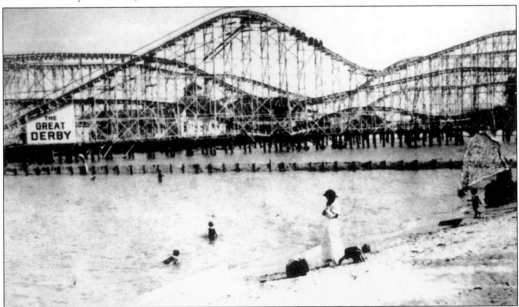

THE GREAT DERBY. One of the grandest roller coasters of its day, the Great Derby was built in 1916 and operated until about 1925. Prior to its construction, a Scenic Railway provided track-based thrills on the boardwalk from 1900 to 1915. (Courtesy Chesapeake Beach Railway Museum.)

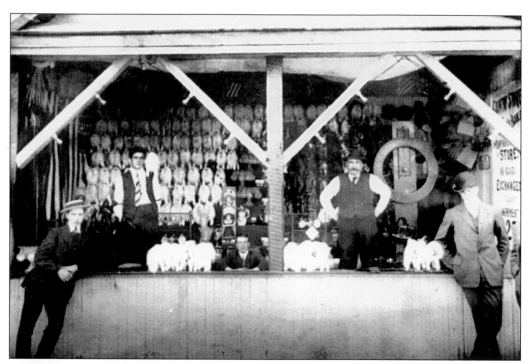

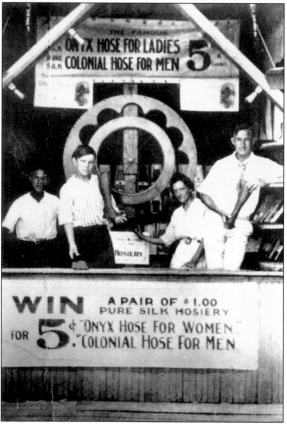

GAMES OF CHANCE. Midway games of all types lined the Chesapeake Beach boardwalk during its earliest days, and prizes were not limited to stuffed animals and kewpie dolls. At the game above, stuffed animals were given as prizes. However, a competitor, left, offered winners something a little more exotic: hosiery. (Courtesy Chesapeake Beach Railway Museum.)

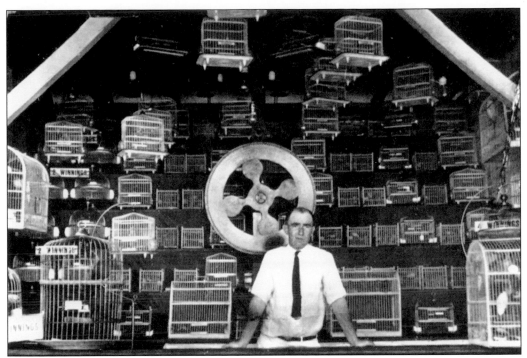

BIRD CAGES. Winners of this boardwalk game walked away with a new pet bird for their efforts. (Courtesy Chesapeake Beach Railway Museum.)

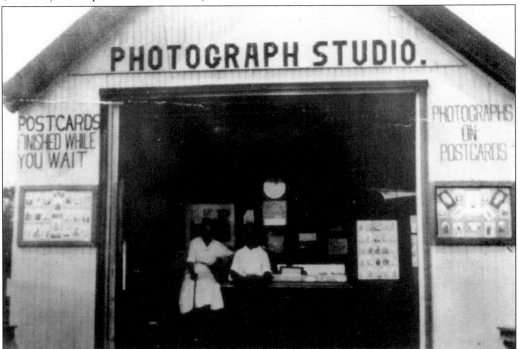

PHOTO STUDIO. Other souvenirs offered during the town's earliest days as a summer destination included posed photographs, taken and processed here. (Courtesy Chesapeake Beach Railway Museum.)

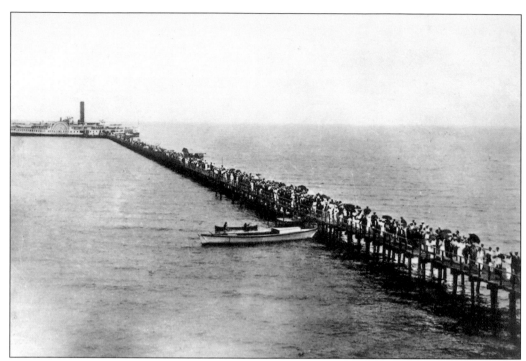

CHESAPEAKE BEACH PIER. Those traveling to Chesapeake Beach by steamboat reached the mainland and its amusements by walking down the area's main entry pier. Similar crowds met the steamers for return trips at the end of the day. (Courtesy Chesapeake Beach Railway Museum.)

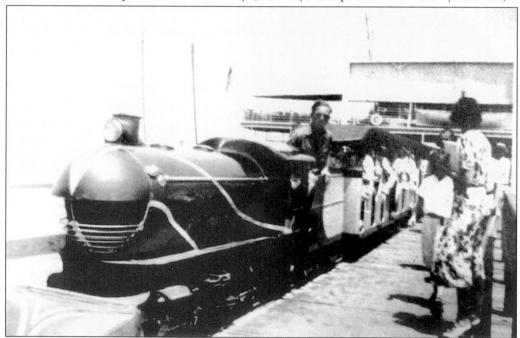

MINIATURE RAILWAY. As the boardwalk matured, so did its attractions. In its later years, guests debarking at the steamboat pier had the opportunity to ride a miniature train directly to the area's amusement district. (Courtesy Chesapeake Beach Railway Museum.)

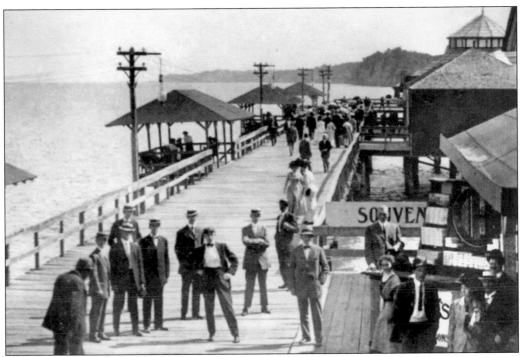

BOARDWALK. Games and souvenir stands were the order of the day along the Chesapeake Beach boardwalk. Devastating storms and fires destroyed many of the area's best-known attractions in the 1920s, including the popular Belvedere Hotel. The town's original Dentzel carousel burned October 31, 1926. (Courtesy Chesapeake Beach Railway Museum.)

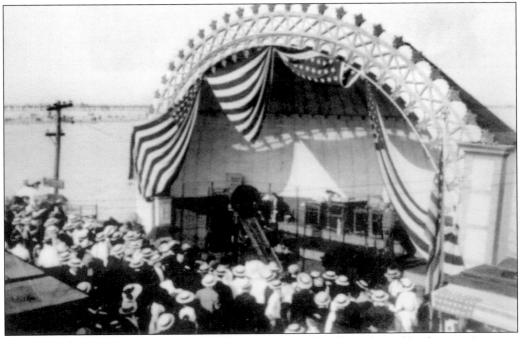

BAND SHELL. Live music also was a big draw on the boardwalk, evidenced by the town's ornate band shell. (Courtesy Chesapeake Beach Railway Museum.)

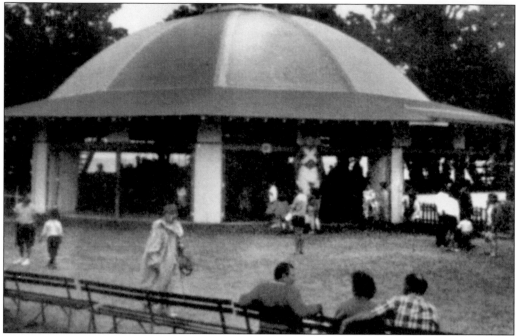

CHESAPEAKE BEACH AMUSEMENT PARK. By 1928, it became clear to many that Chesapeake Beach's boardwalk had seen its best days. Seaside Park opened inland in 1930 as the town's new central amusement area. Following its closing in 1943, the park opened under new management in 1946 as Chesapeake Beach Amusement Park. The park's carousel building is seen here in the 1960s. (Courtesy Chesapeake Beach Railway Museum.)

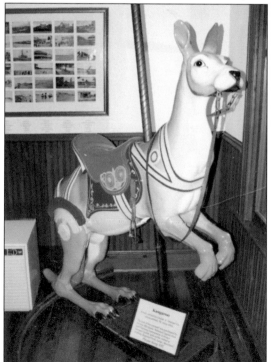

DENTZEL KANGAROO. Operating from 1930 to 1972, the park's carousel contained a number of unusual animals, including a goat, burro, ostrich, and seahorse. Perhaps the most unusual was this kangaroo, which actually traveled up and down as the ride turned. Said to have been hand-carved by Gustav Dentzel, the kangaroo is now on display at the Chesapeake Beach Railway Museum. The carousel itself continues to operate at Watkins Regional Park in Largo, Maryland.

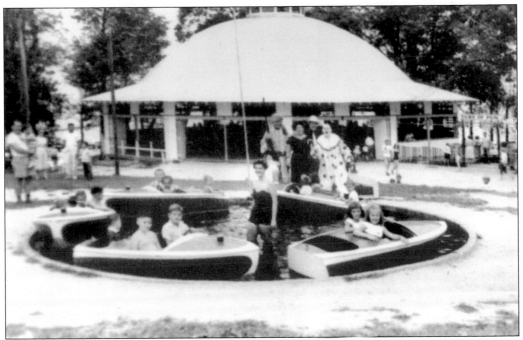

KIDDIE BOATS. Few parks after World War II were complete without at least one kiddie boat ride. Chesapeake Beach was no exception. (Courtesy Chesapeake Beach Railway Museum.)

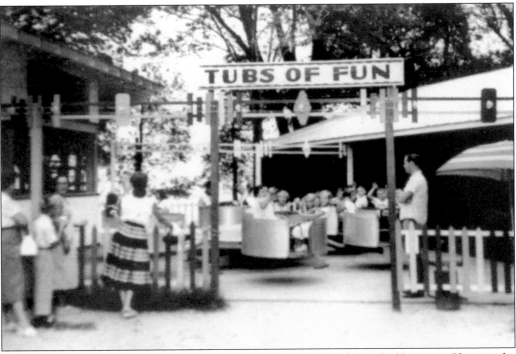

TUBS OF FUN. This dizzying ride was another big attraction at the park. (Courtesy Chesapeake Beach Railway Museum.)

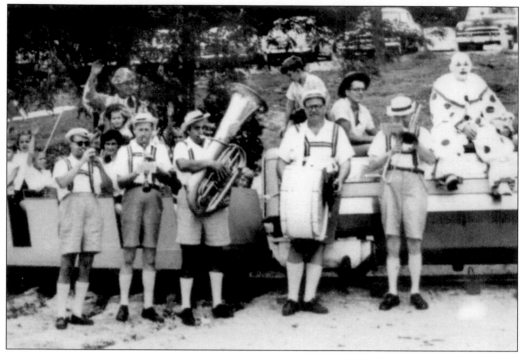

GERMAN BAND AND CLOWN. Live music was an attraction in Chesapeake Beach even after the demise of the boardwalk band shell. For many years, these performers provided entertainment at Chesapeake Beach Amusement Park. (Courtesy Chesapeake Beach Railway Museum.)

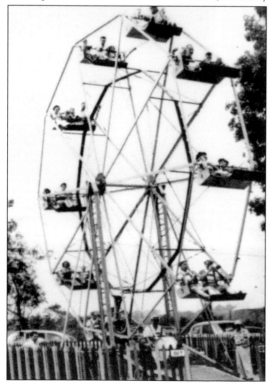

FERRIS WHEEL. The tallest ride at Chesapeake Beach Amusement Park, the Ferris wheel towered over the surrounding area. (Courtesy Chesapeake Beach Railway Museum.)

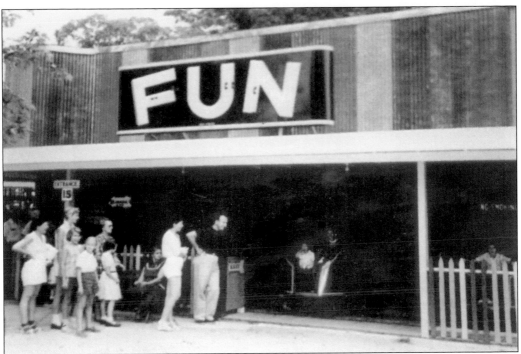

FUN HOUSE. Crowds lined up to ride through the park's fun house in cars manufactured by the Pretzel Amusement Company. A sign on the building advertises the admission as 15¢. (Courtesy Chesapeake Beach Railway Museum.)

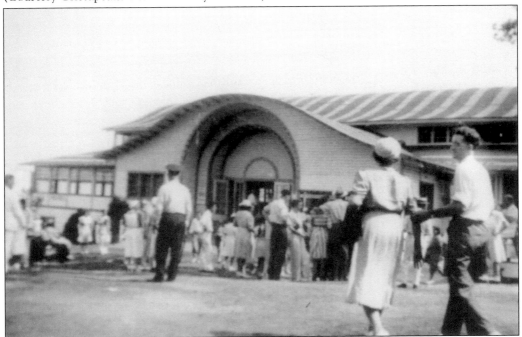

BALLROOM. Like most amusement parks of its time, Chesapeake Beach offered its patrons a grand ballroom. It remained a big draw throughout the park's operation. (Courtesy Chesapeake Beach Railway Museum.)

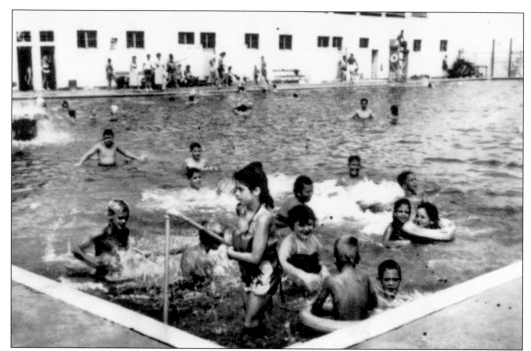

SWIMMING POOL. When Chesapeake Beach's attractions moved inland, amusement seekers had to travel further to the actual beach. The park's swimming pool gave patrons a chance to cool off without venturing back out to the seashore. (Courtesy Chesapeake Beach Railway Museum.)

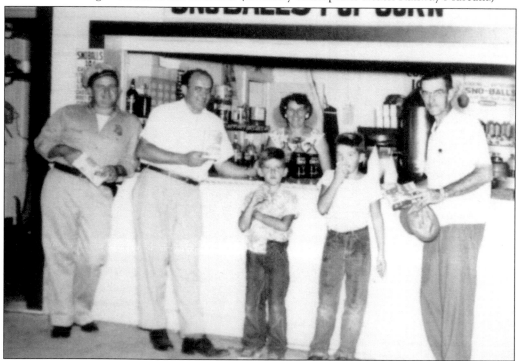

CONCESSIONS. Snowballs and popcorn could be had for a dime at this Chesapeake Beach concession stand. (Courtesy Chesapeake Beach Railway Museum.)

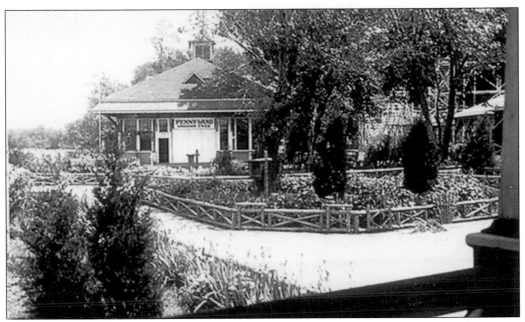

MARSHALL HALL PARK. In 1889, the Mount Vernon Steamboat Company sought a new destination to entice more passengers from its commercial hub in Washington, D.C. Marshall Hall in Charles County proved to be just the right spot. The company constructed a small amusement park that served the town for nearly a century. Amusements throughout the years included the Pennyland arcade, seen here. (Courtesy National Park Service.)

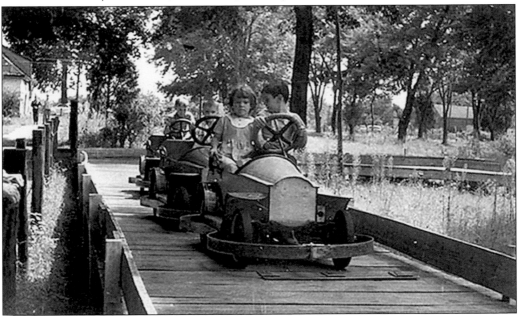

ANTIQUE CARS. Children had fun driving themselves around the park's kiddie car course, as seen in this 1960s view. The 1960s saw big changes for Marshall Hall as it was operated for the first time independently of any steamboat company. A new owner in 1969, Joseph Goldstein, sought to turn the establishment into a Spirit of America theme park. However, those plans never materialized. (Courtesy National Park Service.)

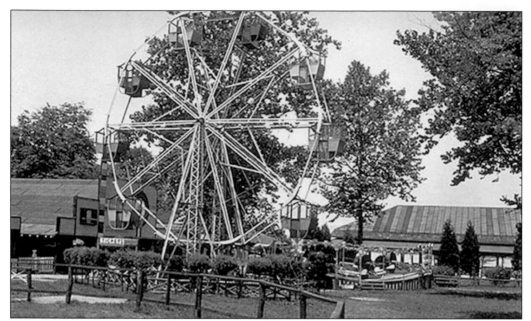

FERRIS WHEEL. From 1905 until its demise, Marshall Hall Park featured a Ferris wheel. Other longtime attractions included a carousel and roller coaster, joined at various intervals by a shooting gallery, miniature railway, and other attractions. In 1976, the National Park Service received authorization to purchase the establishment to expand the adjacent Piscataway Park, seeking to phase out the amusement park by 1980. Its rides were removed in 1982. (Courtesy National Park Service.)

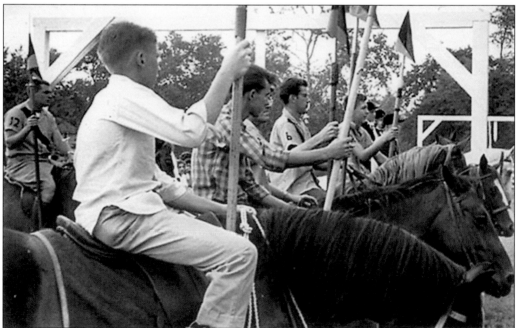

JOUSTING. From its earliest days, Marshall Hall Park featured annual summer jousting tournaments, started in the Marshall Hall community in 1885. The popular contests served as the forerunner of today's Maryland Renaissance Fair. (Courtesy National Park Service.)

Seven

EASTERN SHORE PARKS

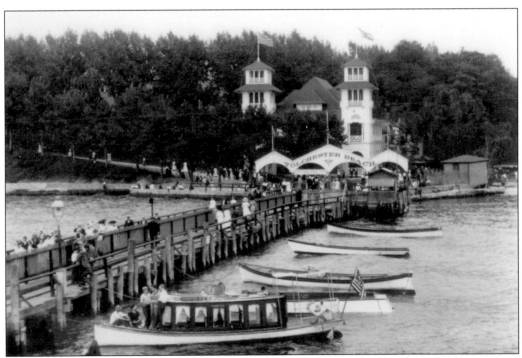

TOLCHESTER BEACH. Boats were lined up as far as the lens could see along the main entry pier to Tolchester Beach in Kent County when this photo was taken on July 4, 1910. The area's biggest draw from 1877 to 1962 was Tolchester Beach Amusement Park, which awaited patrons at the end of the pier.

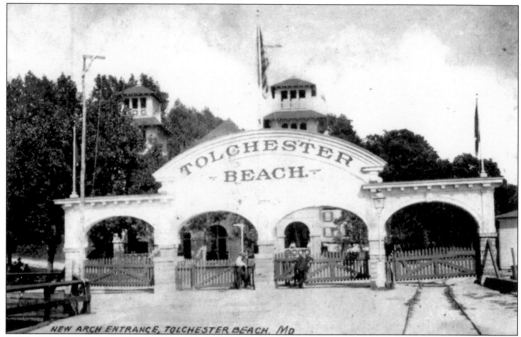

MAIN ENTRYWAY. Renovated several times during the park's 86-year history, the main entry arch to Tolchester Beach was a landmark for the thousands of patrons who swarmed to the park aboard the steamships and ferries that made Tolchester the Eastern Shore's top recreational destination for decades. The version seen here stood in 1916.

CAROUSEL. Tolchester's carousel was hand-powered during its earliest years. By the time this photo was taken in 1888, donkeys provided the ride's momentum from the pit below. The carousel is believed to have been a Dentzel. (Courtesy Tolchester Beach Revisited.)

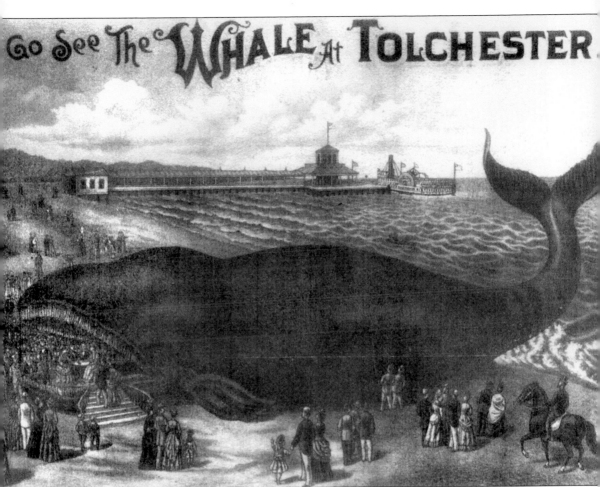

THE WHALE. Perhaps the most unusual attraction of any amusement park in Maryland, the Whale came to Tolchester Beach in 1889. Captured off Cape Cod, Massachusetts, the whale was embalmed in Boston at a cost of $3,000. Following the process, a Philadelphia promoter exhibited the whale at fairs and resort areas throughout the East Coast. During the 1889 season, visitors to Tolchester were invited to peer inside the whale's mouth, with access provided by steps leading up to its jaw. Carpeting placed where the whale's tongue had been allowed social gatherings including ladies' teas and men's oyster dinners to be held inside the animal's mouth. The whale continued as an attraction in other areas until 1891, when health officials in Rochester, New York, noting the whale's deteriorating condition, refused to allow it in that city. The whale's final exhibition came that year at the New York State Fair in Schenectady. (Courtesy Tolchester Beach Revisited.)

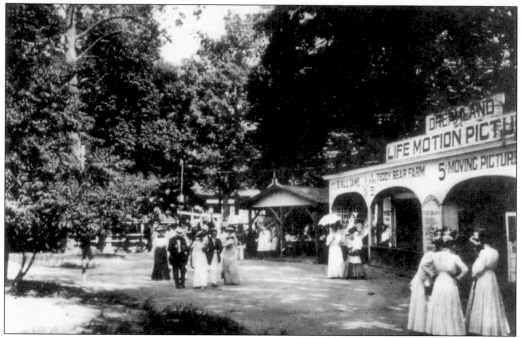

DREAMLAND. Another of the park's popular early attractions, Dreamland offered the chance to view "Life Motion Pictures" for a nickel. The building also housed the Ball Game and Teddy Bear Farm games of chance. Patrons of the Ball Game attempted to knock over a pile of milk bottles with three baseballs for 5¢. (Courtesy Tolchester Beach Revisited.)

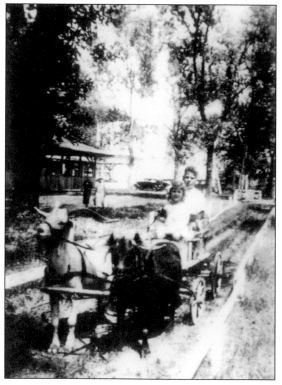

GOAT CARTS. As at other parks, animals as transportation were a draw at Tolchester, evidenced by these children's goat carts. A path took the goats through a specific portion of the park. (Courtesy Tolchester Beach Revisited.)

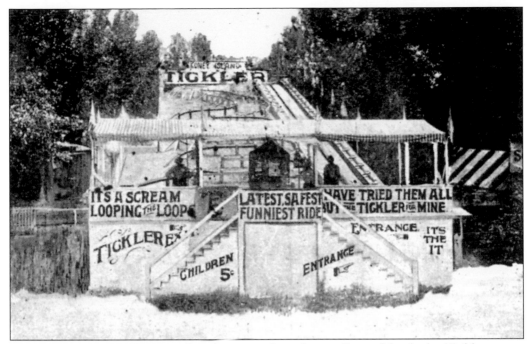

ENTRANCE TO THE TICKLER. Based on popular rides in Coney Island, the Tickler was a Virginia reel attraction. Patrons sat in a circular tub, which ran on curved tracks down a wooden incline.

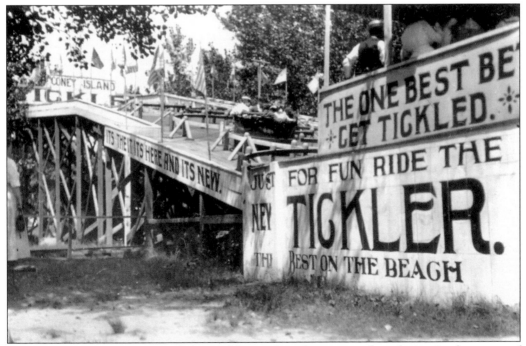

THE TICKLER. Patrons enjoyed the Tickler as this photo was taken during its first year of operation in the early 1900s. The sign to the right advertises the ride as "the one best bet to get tickled."

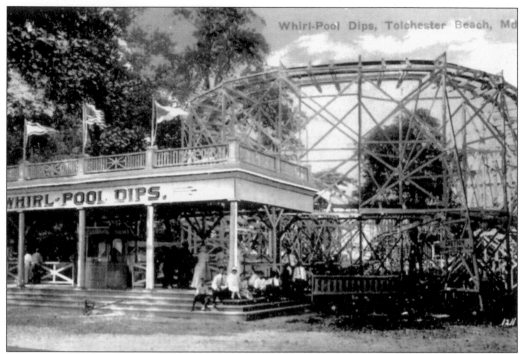

WHIRLPOOL DIPS. Tolchester's largest roller coaster, the Whirlpool Dips, came to symbolize the park for many in the 20th century. In the 1970s, it was one of the final structures demolished as the area was cleared to make way for housing.

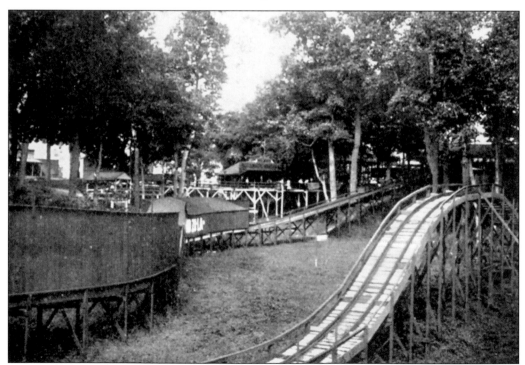

SWITCHBACK. A second roller coaster, the Switchback, also served the park.

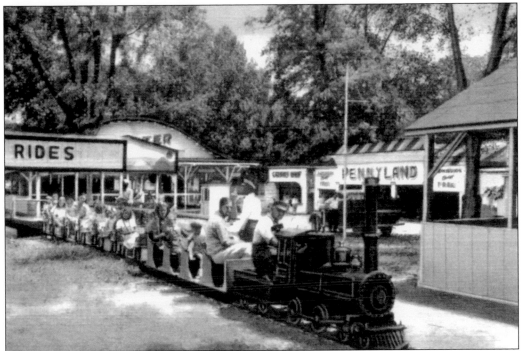

LITTLE JUMBO. Tolchester's miniature train, the Little Jumbo, seen here passing the Pennyland arcade in 1948, was as symbolic of the park as the Whirlpool Dips. A coal-fired steam engine pulled the 12-car train from the late 1880s to the park's final season. Once the park closed, the train served a new generation of patrons as part of the Joy Line of the Toy Train Museum in Harpers Ferry, West Virginia.

SHOOT THE CHUTE. Like larger parks of the time, Tolchester also featured a Shoot the Chute ride, enjoyed by many during its stay at the park. (Courtesy Tolchester Beach Revisited.)

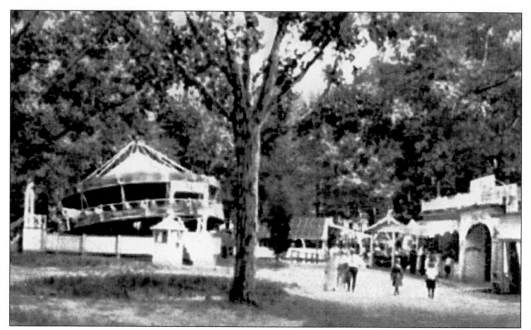

THE TOP. A non-mechanical suspended platform ride, the Top, seen to the left in this view, sent patrons up, down, and around through a group effort. Guests were expected to push themselves off the ground, and as one edge of the circular platform rose, another came down. The process was repeated until the ride operator called a halt and invited in the next crowd. Note the Dreamland building at the right.

WHIP. The Tolchester Beach of the 1940s featured a Whip, as well as a Skooter pavilion, the latter of which is seen to the far right in this view. Admission to the Whip in the park's final years was a quarter, which was requested at the ride's exit rather than its entrance.

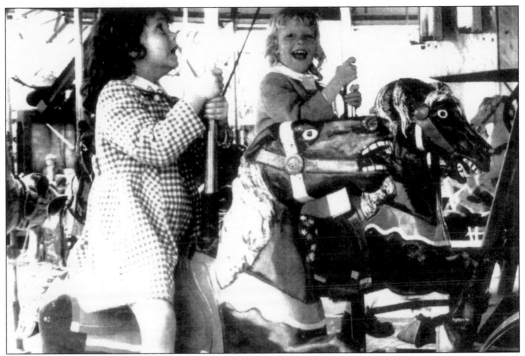

CAROUSEL. The Tolchester carousel of the 1950s was a vast improvement over its earlier Dentzel model. The mechanically powered ride was built by the Herschell-Spillman Company. (Courtesy Tolchester Beach Revisited.)

KIDDIE BOATS. Another example of the circular boat ride placed in many amusement parks from 1936 to 1952, Tolchester's was manufactured in the 1940s. (Courtesy Tolchester Beach Revisited.)

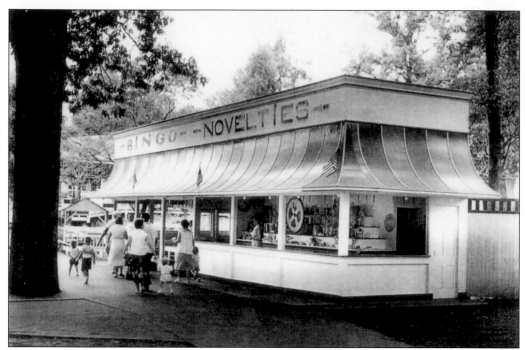

NOVELTIES. Tolchester Beach pennants, glassware, and other souvenirs were given away as prizes at this booth. The 50-star American flag on top dates this photo to the park's final years, in 1959 or later. (Courtesy Tolchester Beach Revisited.)

LAUGHING SAL. From the early 1930s to the late 1950s, few reputable amusement parks in the United States could say they had a real fun house without the attraction of a Laughing Sal or a reasonable knockoff. Tolchester's version, a knockoff and a male one at that, is seen here with two friends. (Courtesy Tolchester Beach Revisited.)

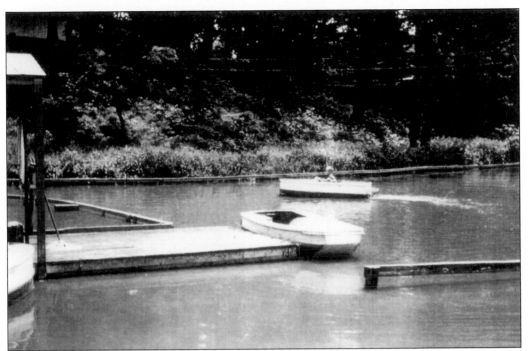

LAKE BOATS. Popular through the park's final days, the Lake Boats allowed children to operate gasoline-powered launches on the park's lake. Admission was a quarter. (Courtesy Tolchester Beach Revisited.)

ANTIQUE CARS. Tolchester offered yet another variation on the kiddie car craze that hit amusement parks in the 1950s. (Courtesy Tolchester Beach Revisited.)

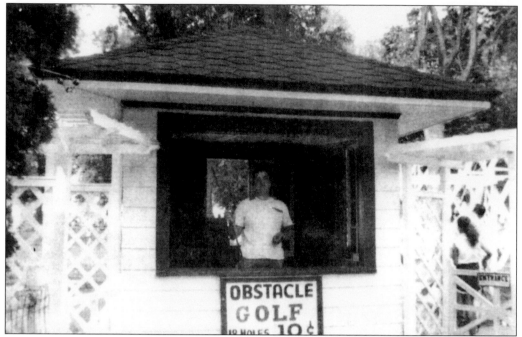

OBSTACLE GOLF. Tolchester Beach Amusement Park offered its own variation of miniature golf during its waning years. Greens fees were 10¢. (Courtesy Tolchester Beach Revisited.)

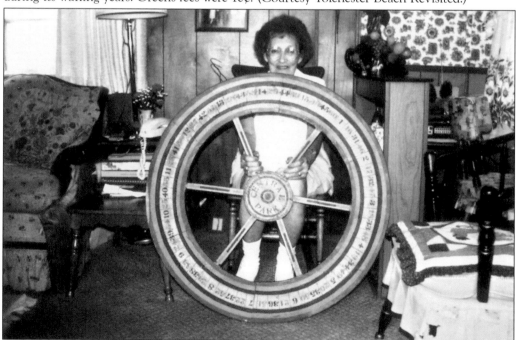

CENTRAL PARK. This gaming wheel, held by Dora Sterling, is one of the only surviving pieces of the three amusement parks that once served Crisfield, the state's southernmost city, in Somerset County. Opened in the 1920s as Hastings Electric Park on Main Street Extended, Central Park featured, among other attractions, a carousel, candy stand, and outdoor movies with piano accompaniment, second-run from the Arcade Theater downtown.

Eight

TRIMPER'S RIDES AND AMUSEMENTS

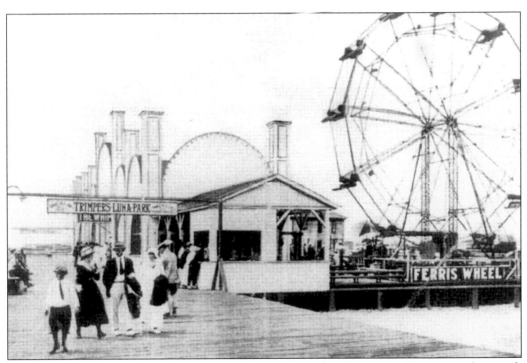

WINDSOR RESORT. Coming to Ocean City in 1890, Daniel and Margaret Trimper made a mark on the town that still stands today. By 1893, they owned two hotels, the Eastern Shore and the Sea Bright, as well as other property on the boardwalk. Following a storm that destroyed the Sea Bright, Daniel Trimper rebuilt the structure based on Great Britain's Windsor Castle in 1900. Combined with the Eastern Shore, a movie theater, and the Luna Park amusement area, the complex became known as the Windsor Resort and started a vacation boom in the area that has only grown since. (Courtesy Trimper's Rides and Amusements.)

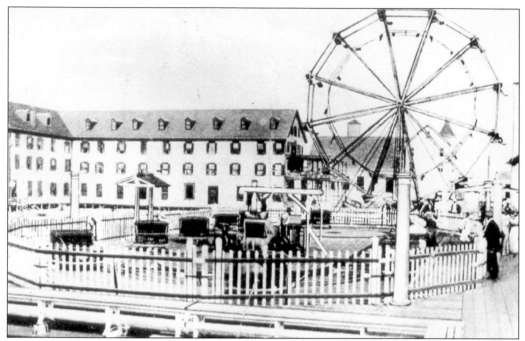

FERRIS WHEEL AND WHIP. These were some of the earliest rides at Trimper's Luna Park. A hurricane in 1933 that carved the inlet near where Trimper's sits today washed away many of the original rides. However, that did not deter the Trimpers from persevering and prospering in the growing Worcester County resort town. (Courtesy Trimper's Rides and Amusements.)

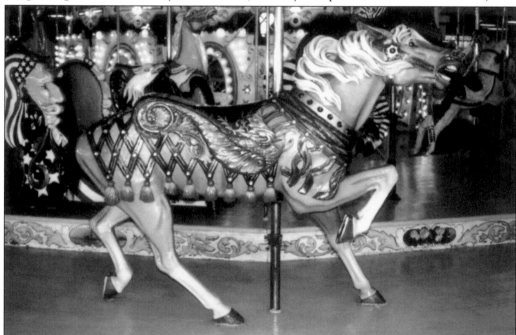

CAROUSEL HORSE. The detailing on this horse shows just how intricate the carving was on Trimper's original carousel. The ride has operated continuously for more than a century and has been carefully maintained since its installation.

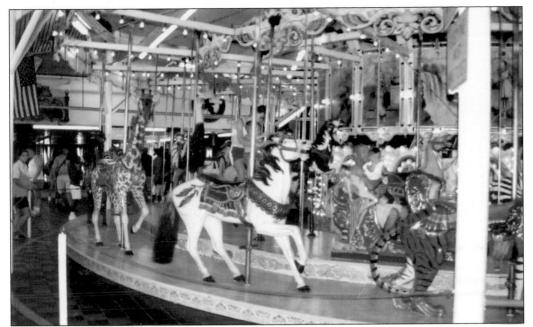

TRIMPER'S CAROUSEL. Perhaps the most momentous occasion in Trimper's history came in 1902, when Daniel Trimper purchased a 50-foot-round steam-powered carousel made by the upstart Herschell-Spillman Company. Only the second carousel made by the manufacturer that went on to become one of the amusement industry's biggest names, it remains today the oldest existing specimen of that company's work and the crown jewel of Ocean City's premier amusement park.

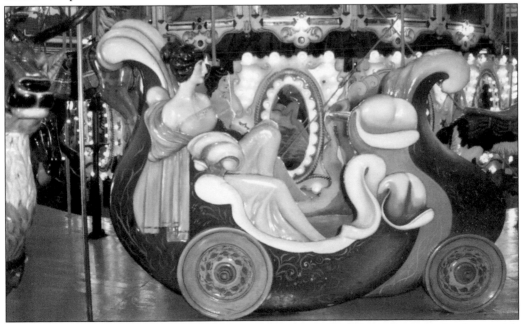

GONDOLA. This gondola is one of three appearing on the Trimper's carousel, along with a rocking chair and 45 animals. Original admission on the ride was a nickel. As of 2004, admission was $1.60. (Courtesy Trimper's Rides and Amusements.)

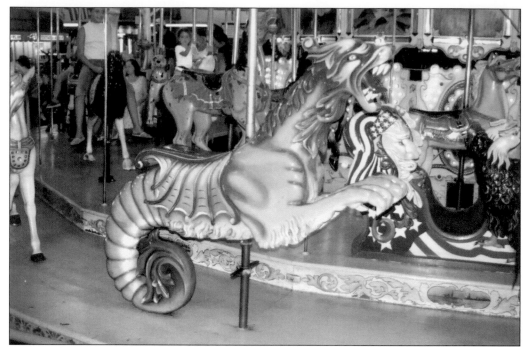

OTHER ANIMALS. Unlike many traditional carousels, the one at Trimper's features a number of animals other than horses. Some favorites include the dragon, above, and the giraffe, below.

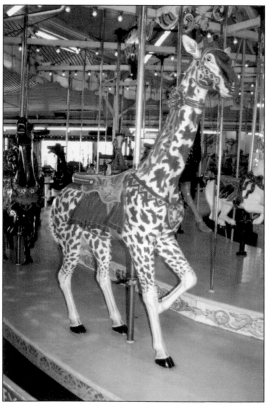

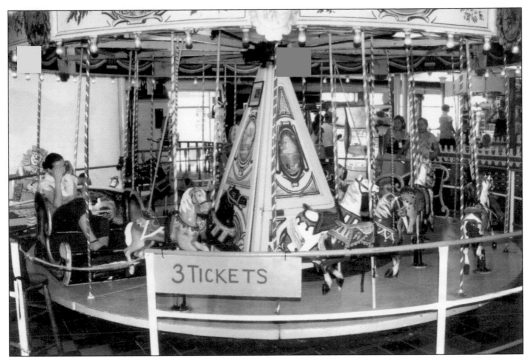

KIDDIE CAROUSEL. This antique ride has served Trimper's since the 1920s, sitting mere footsteps away from the much larger 1902 carousel.

TICKET BOOTH. Used in the 21st century for decoration rather than ticket dispensing, this ornate antique ticket booth is just one more example of how the Trimper family has preserved its amusement park heritage.

FAIRY WHIP. Another relic of the past still operating at Trimper's, the Fairy Whip is a child-sized version of the larger ride that once graced the boardwalk at Trimper's Luna Park.

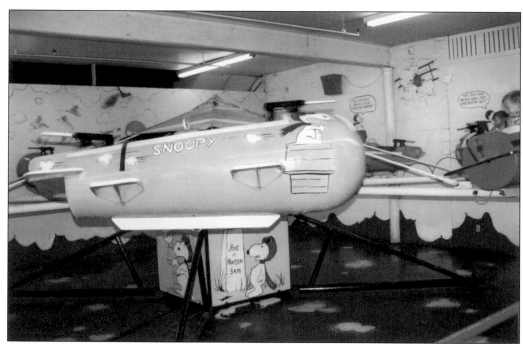

AIRPLANES. This vintage hub-and-spoke metal airplane ride has provided thrills for generations of Trimper's younger patrons. The staggered buzz of their attached battle guns with little fingers on the buttons that make them blare has provided part of the park's ambient sound for decades.

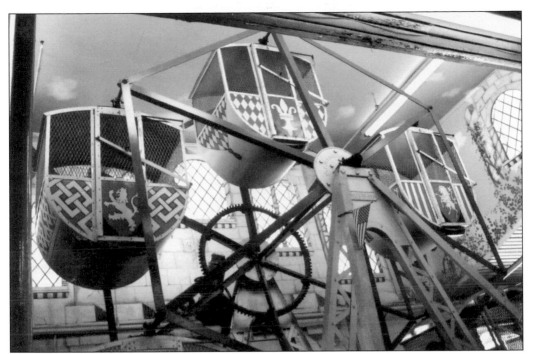

KIDDIE FERRIS WHEEL. While only children may ride, many adults appreciate the historical value of Trimper's kiddie Ferris wheel, in operation at the park since the 1920s.

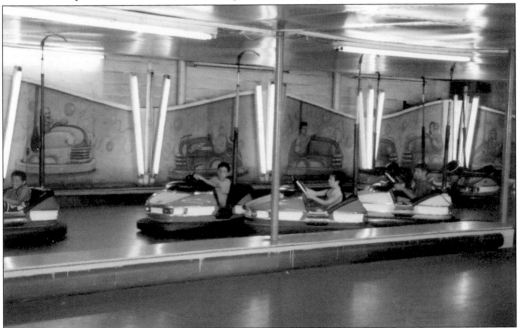

BUMPER CARS. The Trimper's version of this ride varies from many others because of the divider in the middle of the floor that keeps the cars traveling one way and gives them an extra wall to bump. Paintings from the 1930s provide the pavilion's interior decor, while the outside features ornate clown signs, a gaming wheel, and other amusement park memorabilia from the early 20th century.

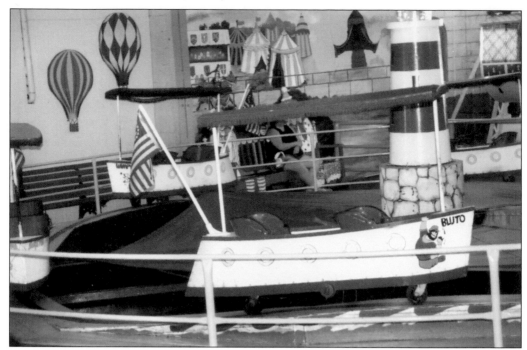

RAIL BOATS. These kiddie boats from the first half of the 20th century ride not on water, but on a rail to simulate waves. Once painted to resemble battleships, they have been a favorite at Trimper's for decades.

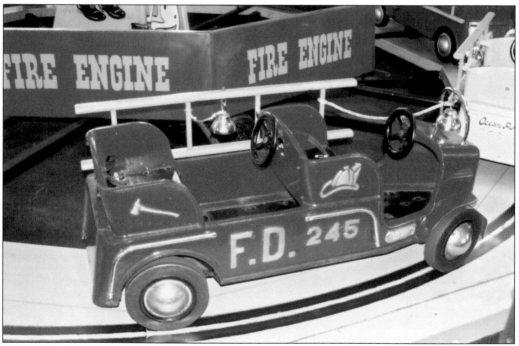

FIRE ENGINES. Another longtime Trimper's favorite, the fire engines pay homage to local volunteers by sporting the names of area volunteer fire departments.

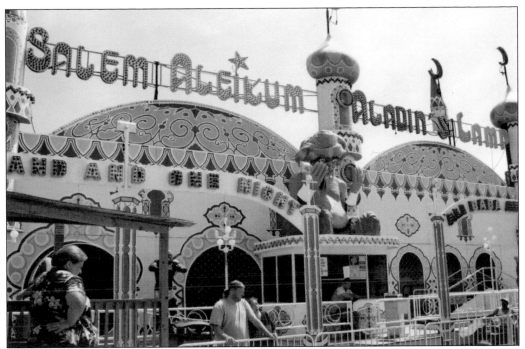

ALADDIN'S LAMP. For years, this fun house has stretched across the back side of Trimper's main building. Traditional gags inside include moving floors, a rotating platform, and a revolving barrel.

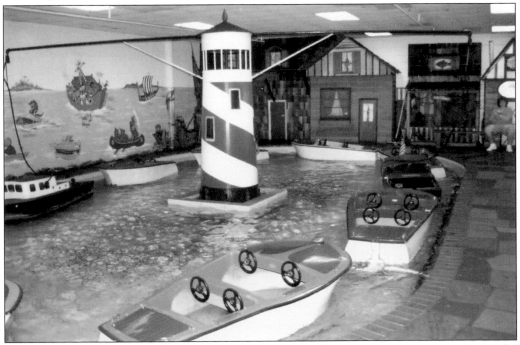

KIDDIE BOATS. One of the newest indoor rides at Trimper's, this decades-old kiddie boat attraction leads children in circles past waterfront shanties and a mural of watercraft through history.

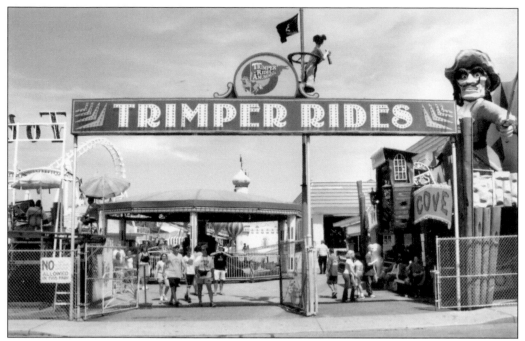

TRIMPER'S ENTRANCE. The park's main entrance ushers patrons from the Ocean City boardwalk. In 1997, nationally syndicated cartoonist Bill Griffith used this sign to introduce Trimper's to the world, featuring the park as a backdrop for his newspaper comic strip "Zippy the Pinhead." At the time, the back side of the sign featured one of the title character's signature sayings, "Are we having fun yet?"

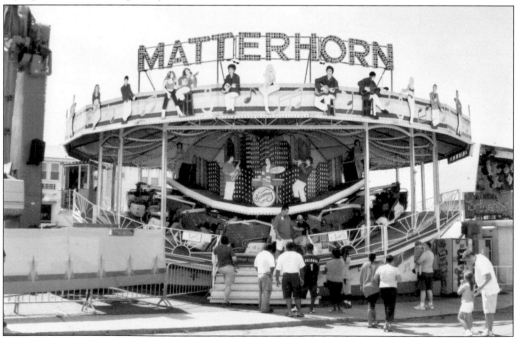

MATTERHORN. Featuring the plywood cut-out band the Switcheroos, the Matterhorn has been a staple of Trimper's for decades.

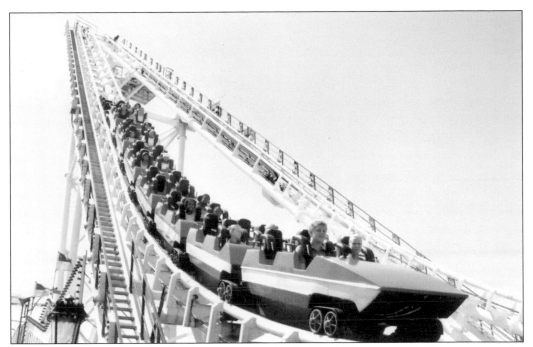

TIDAL WAVE. Trimper's added its biggest thrill ride, the Tidal Wave, in 1985. The next year, the roller coaster, as well as the rest of the park, was featured in the Universal Studios film *Violets Are Blue*, starring Sissy Spacek and Kevin Kline.

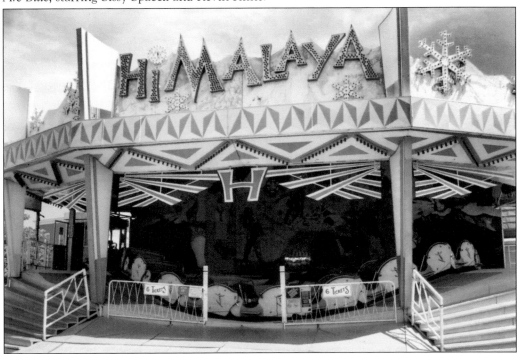

HIMALAYA. The Himalaya spins riders on a platform past a continuous diorama of a ski resort before reversing direction, often with the refrain, "We're going to slow you down and turn you around."

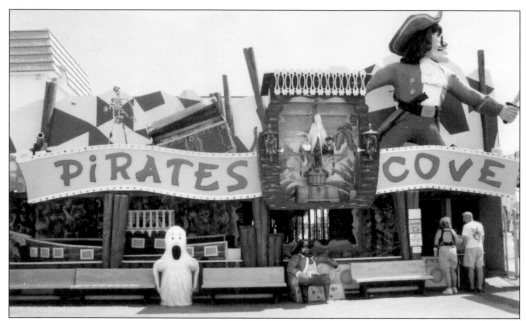

PIRATES COVE. This 1971 fun house stands as one of Trimper's two operating monuments to amusement park legend Bill Tracy, who designed hundreds of dark rides for parks throughout the country. Inside, patrons traverse through pirate-infested hallways and moving floors, among other obstacles. In 2004, Pirates Cove was one of only three Tracy-designed walk-through attractions left operating in the United States.

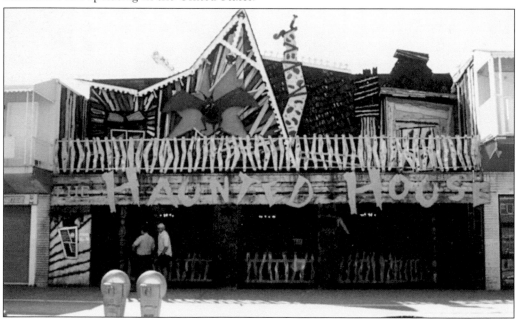

HAUNTED HOUSE. Located at the site of the former Windsor Theater on the boardwalk, this 1962 dark ride marked Tracy's first job for Trimper's. In 1988, the attraction received a makeover using Tracy-designed props from the former Ghost Ship dark ride at Ocean City's defunct Playland amusement park. The additional gags required an expansion of the Haunted House to two stories, making the ride twice as long.

118

Nine

OCEAN CITY PARKS

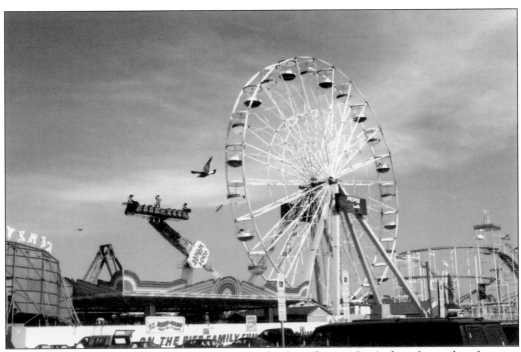

OCEAN CITY PIER RIDES. The giant Ferris wheel at Ocean City's famed pier has become a Maryland landmark, flanked here on the left by the 1001 Nacht and on the right by the Looping Star roller coaster.

VIEW FROM THE 1960S. The amusement section on the pier has evolved throughout the years. In this 1960s view, attractions included a Paratrooper, Octopus, and several kiddie rides.

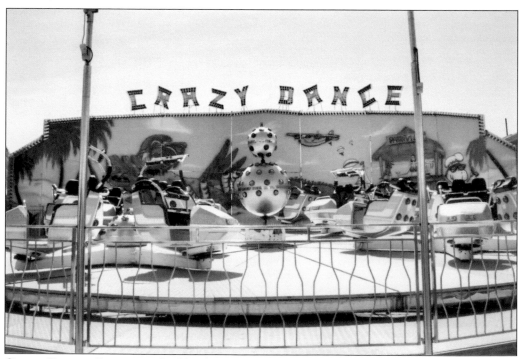

CRAZY DANCE. Spinning rides like this one have long been a pier favorite.

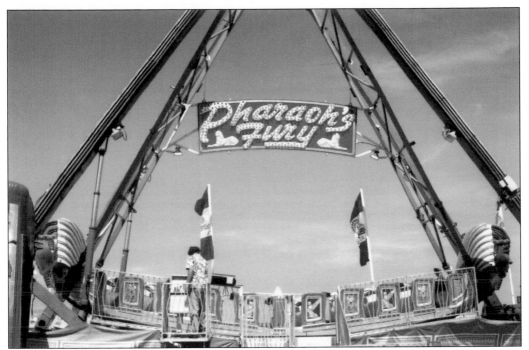

PHARAOH'S FURY. Swinging chariots that combine dips and inverted suspension like this Egyptian-themed ride also have a history of success at amusement parks.

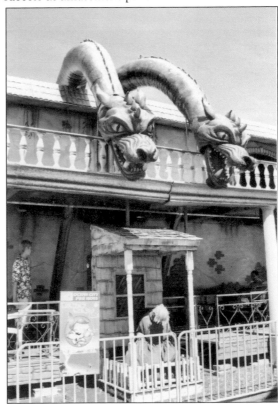

HAUNTED HOUSE. Attractions like this have a long history in Ocean City. In the 1980s, the walk-through haunted house Morbid Manor was one of the pier's biggest attractions. This ride-through replacement was added in the mid-1990s.

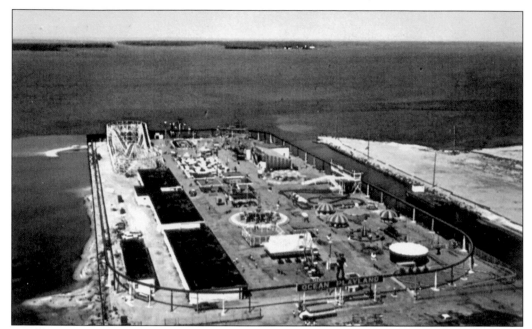

PLAYLAND. Opened on 65th Street in the 1960s, Playland provided thrills for many patrons. Operating under the name Ocean Playland in this 1960s view, the park featured, among other attractions, a monorail that gave guests a grand-circle view of the grounds as well as the natural beauty of the ocean. According to early promotional items, the park's construction cost $2 million.

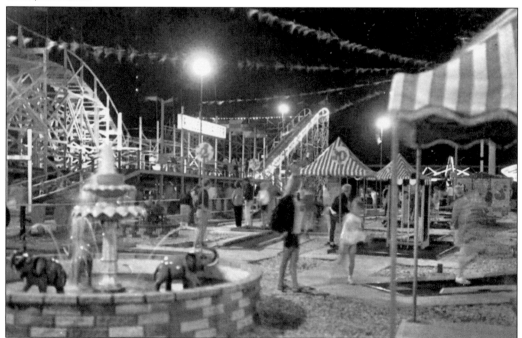

PLAYLAND AT NIGHT. This c. 1970 postcard view of the park highlights Playland's miniature golf course. The park's roller coaster is seen in the background of this image and in the upper right of the view above.

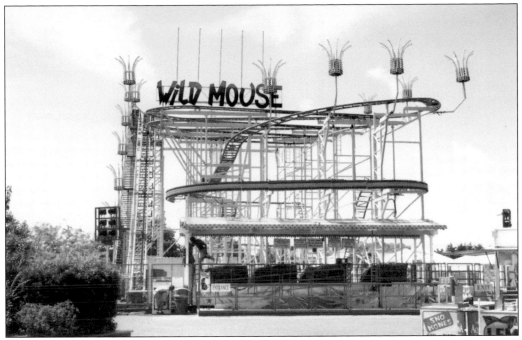

WILD MOUSE. Long an amusement park staple, the Wild Mouse lives on at Jolly Roger Amusement Park, located at 30th Street and Philadelphia Avenue. This version came to the park in 2002.

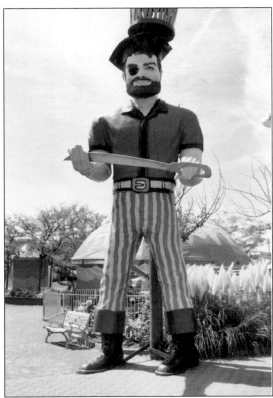

JOLLY ROGER. Manufactured by International Fiberglass in the 1960s, Jolly Roger's namesake pirate is similar to the one that stood atop the main entryway of Playland, as seen on the opposite page. The pirate's mass-produced design originally was created to help gas stations and auto repair shops increase business in the 1960s. During that era, these fiberglass behemoths often held giant mufflers or tires outside repair shops to promote the services offered within.

123

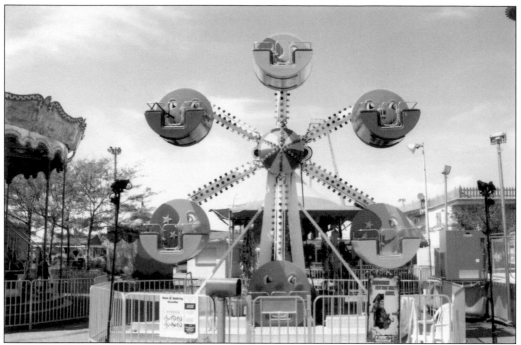

GIANT WHEEL. Jolly Roger is well known for its kiddie rides, including this one, located near the park's entrance in 2004.

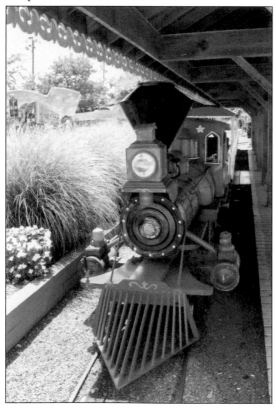

MINIATURE RAILWAY. Like many of Maryland's great amusement parks of the past, Jolly Roger features its own miniature train.

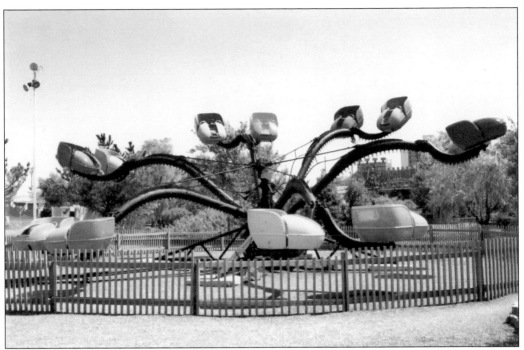

OCTOPUS. The Octopus, another amusement park favorite, also has a home at Jolly Roger.

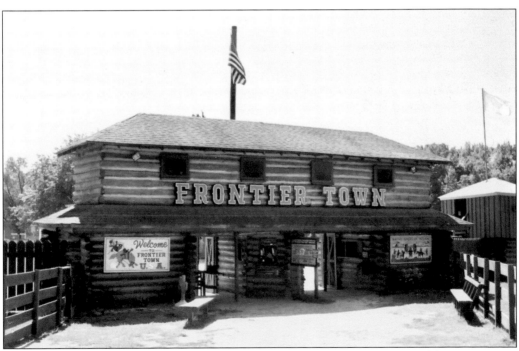

FRONTIER TOWN. Fresh off his work for The Enchanted Forest, Baltimore fabrication artist Howard Adler lent his talent to a new amusement park being planned in West Ocean City. The result, Frontier Town, opened in 1959 and has operated continuously since. Here, the main entry fort welcomes patrons inside to the Old West.

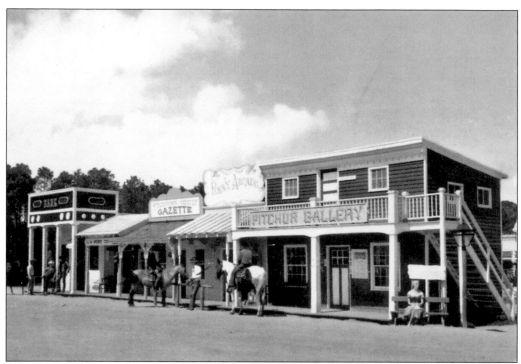

MAIN STREET. Frontier Town's Main Street has changed little since this photo was taken in 1961.

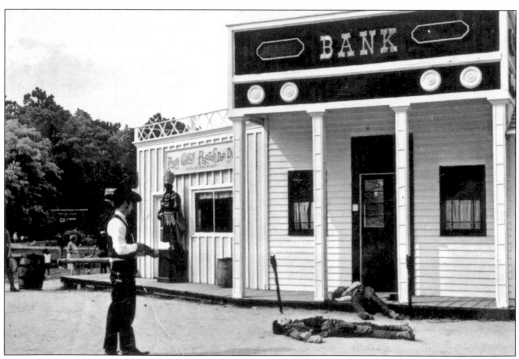

BANK ROBBERY. Something exciting happens nearly every hour at Frontier Town from Memorial Day weekend to Labor Day. The town's bank has been robbed every warm, sunny day since 1959. However, the sheriff always wins in the end, as seen in this 1969 view.

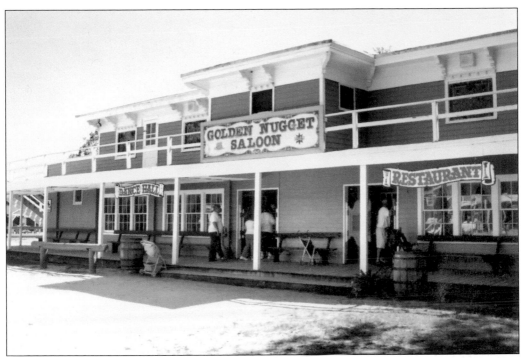

GOLDEN NUGGET SALOON. The saloon features a restaurant and daily performances by can-can dancers, giving the park even more Old West flavor.

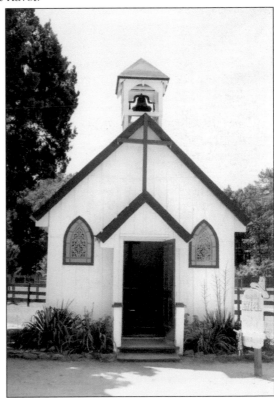

FRONTIER CHAPEL. Like The Enchanted Forest, Frontier Town also features a church along its dirt streets. A sign in front advises cowboys to leave their guns outside. At least one has obliged, as a six-shooter forever hangs from one of the sign's pegs.

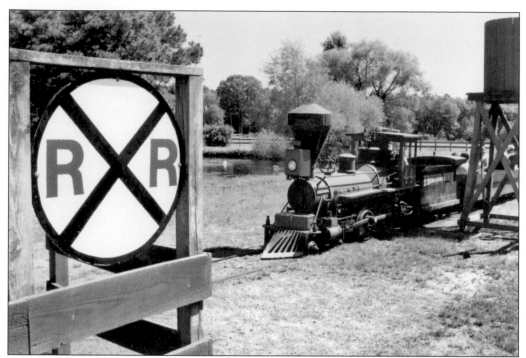

FRONTIER TOWN TRAIN. This miniature railway takes riders on a tour of the park. Other attractions include pony rides, paddle boats, and the opportunity to pan for gold.

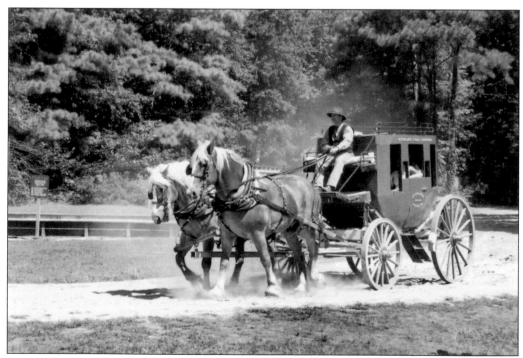

OVERLAND STAGE COMPANY BOARDING AT THE WELLS-FARGO STAGE DEPOT. This stagecoach company offers scenic rides through Frontier Town.